PHOTOGRAPHING CHILDREN

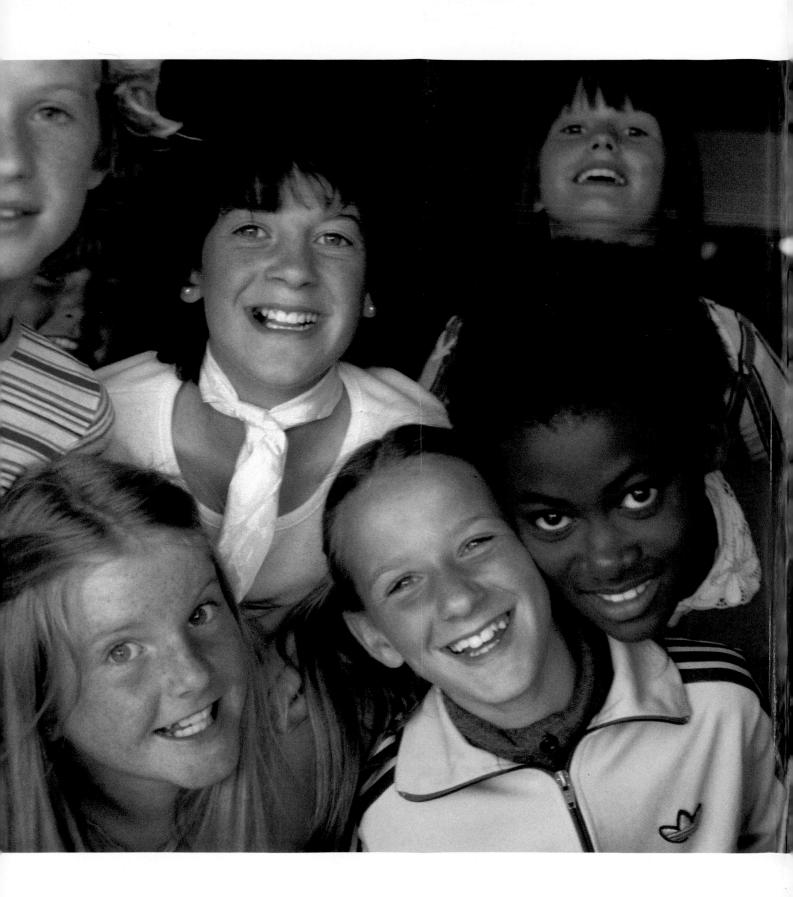

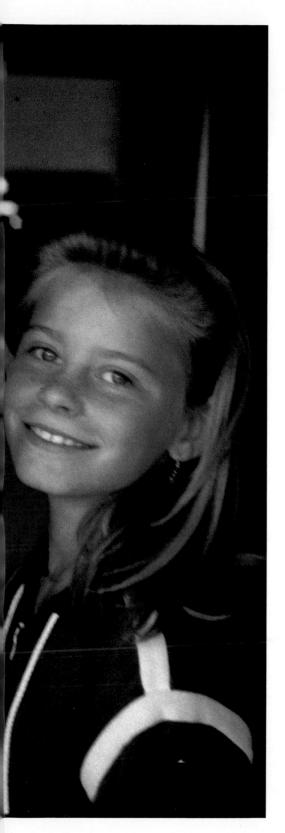

Photographing Children

SUZANNE SZASZ

AMPHOTO An Imprint of Watson-Guptill Publications/New York Editorial Concept by Marisa Bulzone Edited by Liz Harvey Designed by Bob Fillie Graphic Production by Ellen Greene

Copyright © 1987 by Suzanne Szasz

First published 1987 in New York by AMPHOTO, an imprint of Watson-Guptill Publications, a division of Billboard Publications, Inc., 1515 Broadway, New York, NY 10036

Library of Congress Cataloging in Publication Data Szasz, Suzanne.

Photographing children.

Includes index. 1. Photography of children. I. Title. TR681.C5S93 1987 778.9'25 87-11357 ISBN 0-8174-5469-1 ISBN 0-8174-5470-5 (pbk.)

All rights reserved. No part of this publication may be reproduced or used in any form or by any means—graphic, electronic, or mechanical, including photocopying, recording, taping, or information storage and retrieval systems—without written permission of the publisher.

Manufactured in Japan

1 2 3 4 5 6 7 8 9/93 92 91 90 89 88 87

This book is dedicated to the parents who allowed me to photograph their children.

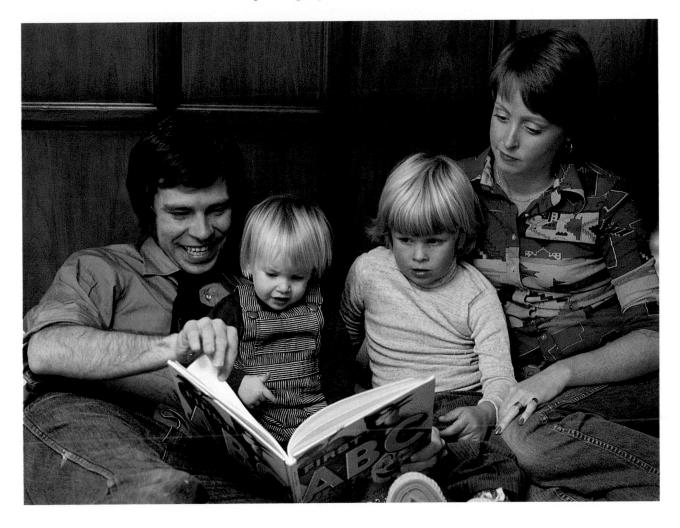

CONTENTS

INTRODUCTION: The Basics of Photographing Children 8

TECHNICAL BASICS 20

When the Sun Shines 20 Filling In Against the Sun 22 Without Sun 24 Available Light Indoors 28 Direct Flash 32 Bounce Flash 36 Tungsten Lights 40

COMPOSITION BASICS 44

Exercises for Better Technique 44 Different Angles 46 Foregrounds 48 Backgrounds: Subdued 49 Backgrounds: Emphasized 50

PUTTING THE BASICS INTO PRACTICE 52

The Everyday World 52 Color and Content 58 Color Versus Black and White 64 Photographing in Black and White 66 Portraits 82 Babies, Babies, Babies 86 Children at Different Ages 88 More than One 92 Children and Parents 98 Children and Pets 104 Photo Sessions Can Be Fun 108 Children's Choices 112 Children at Play 116 Off to School 120 Children and Sports 124 Special Occasions 128 Unusual Expressions: Not for the Reject Pile 132 Vacations to Remember 136 A Sequence: The Two Balloons 140 What Children Learn from Taking Pictures 142

INTRODUCTION: THE BASICS OF PHOTOGRAPHING CHILDREN

I hope you are reading this book because you are enthusiastic about photographing children. Perhaps you have even become aware that you have a special bond with them.

That's what happened to me. I started photographing relatively late in life, after I had accepted that I was not going to have children of my own. I was immediately drawn to them as subjects, and soon realized that I had found the ideal substitute for what I was missing. Since then I have spent most of my time working with children. I frequently followed up my original assignment and went back to see how the children had grown.

You, too, must have a good reason for being attracted to photographing children; this enthusiasm will lead you to produce good work. Besides the usual rewards of discovering more and more about your field, you will benefit in another way: you will learn about *being* a child. Because we forget nearly everything about our first years, it is exciting to observe children and to relive this important time.

FIRST CONSIDERATIONS

Your Camera. Today's automated cameras can boggle the mind. But I think they can help you to simplify your photography if you know what they are capable of. You should understand such simple concepts as the effect of a fully open versus a closeddown diaphragm or the uses of differential focusing.

Do you think that a typewriter-computer that automatically corrects your spelling is the best way to learn your language? I hope not. I would rather learn to spell mostly by trial and error and know how to consult a dictionary.

So, by all means, get some of the new superstar cameras,

but don't expect them to do your job. Be sure to make tests that show the result of letting the camera do everything and compare them to what you get when *you* decide on the lens opening and/or exposure time. After you have done such tests, try to develop speed and facility, which will often be better than will fussing endlessly in quest of perfection.

As New York Times critic Andy Grundberg recently noted, "Consistent exposure metering in the real world will remain a matter of human skill, experience and intuition, not high technology."

I hope that you won't be disappointed if I don't talk more about equipment. There are many good books on the different cameras, and I trust you have read and reread your camera manual several times.

I believe in simplicity when it comes to equipment. Commit yourself to one brand or

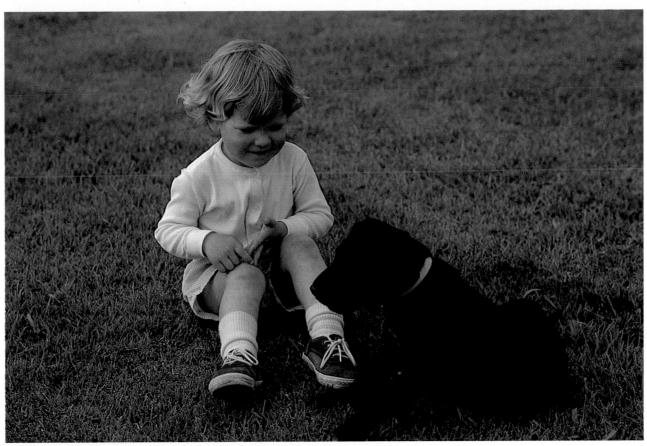

In some situations, there is no "right" exposure. What fits the blonde child is not correct for the black dog, and no compromise would work.

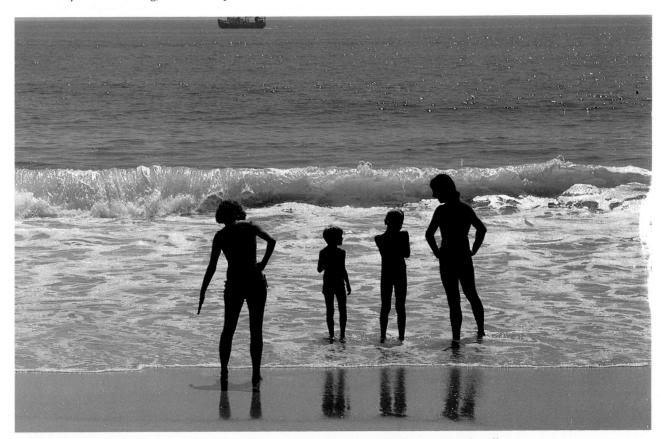

In this photo, exposing the ocean properly and letting the bathers become silhouettes work well.

INTRODUCTION

design of camera, for which all lenses focus in the same direction and are completely interchangeable and all bodies wind and load in the same manner. I haven't regretted sticking for more than 30 years with Minoltas. I have come to handle them as semiautomatically as I drive my car or use a typewriter.

As for accessories, I am unable to combine the use of a tripod with the way I like to move about. I carry filters and sunshades, and that's about all. I put my extra film into a pouch on a belt and add a good felt-tipped pen so that I can write on film ends if I need to. When I have to carry a great deal of film, I keep it in a well-insulated bag (the type usually sold as a food or picnic bag in most five-andten stores).

I also recommend separating your equipment evenly into two bags, so that one shoulder does not have to do all the carrying, which can result in progressive injury to your spine. (Check with your doctor; you will learn how important this is for your health.)

In the next few pages, I mention some technical problems that have come up time after time in my own work. They will also be discussed in more detail later. Let's think of some nontechnical problems here, such as:

Composition. I am not referring to aesthetic rules and values because none exist. (Who would have believed even a few years ago that chopped-off heads and random, confusing elements would be hailed in major museums?) But if you often regret that you include unnecessary details, you should learn to "crop" on the film before taking the picture.

Approach. If all your photographs look alike and seem boring, you should try a new approach. Do you

immediately instruct your subjects where and how to sit or stand and how to smile? Why not trust chance and your subjects' temperaments? Of course, you will have to put more physical energy into following a lively child rather than instructing him or her to sit on a chair and smile.

Even planned pictures don't have to be boring. Without giving direct orders, you can set the scene and guide the conversation so that you can catch what you are after. Obviously, there are times when it is important that you "produce" a certain picture, but such a shot needn't be the result of strict posing. Try recording a birthday or picnic without directing anyone. You will be surprised how much more interesting your photographs will become. You may even have fun discovering the real world of children.

From the realistic to the arranged, you can handle your subject in many ways. Your choice depends on what your aim or assignment is. If you are working on a documentary about children living in slums, you will be deceiving your audience if you try to hide ugly surroundings. For example, you should show a peeling wall if it is part of a child's environment; you should not show it if the wall is peeling because of a temporary mishap and presents a distorted picture of the child's surroundings. But if you are working for a private client or doing an advertisement, you will be considered sloppy if you *don't* try to hide what is ugly or inconsistent.

There are more ways to have the proper background for your photos than by moving into another room. You can, for example, learn to control your background by limiting your depth of field or by finding another angle from which to shoot. Move the camera to the left or right, or higher or lower.

DARE TO MAKE MISTAKES!

Looking at the best photography—whether at exhibits or in books—is sure to develop your taste and widen your horizon. It can also make you feel that everything has already been photographed. Don't believe it! Even if you tried, you couldn't duplicate another person's work. For better or worse, all photographers put their mark on their work, as different and personal as their handwriting or tone of voice.

Learning from books and lectures is admirable, but nothing equals learning by experience. The first rule for producing good photographs is to be there. The second: to become friendly with other photographers and talk shop.

I cannot teach you how to produce perfect pictures every time. I don't even want to. Sure, you can set up two umbrellas, learn the correct exposure, and repeat this setup with perfect technical results every time. But you will then miss dozens of shots happening outside the reach of your umbrellas. I prefer risking marginal exposures, using one light instead of two, and settling for not-so-perfect whites by forgoing umbrellas. (I do not include technical data for most of my pictures because what I do must be obvious. And is it really important whether I shot at 1/100 sec. or 1/250 sec.? Or whether the f-stop was f/5.6 or f/8? Of course, I will mention anything that is special or that needs explanation.)

Using a fast shutter speed is safer than risking blurred action, yet imagine how poetic and lifelike this may be.

If you disobey your automatic camera that begs you to "Use flash! Please use flash!" some parts of your photograph may remain dark. Think, though, how much more effective this may be. Similarly, wide-angle lenses distort your subject. But if the

The white blanket was useful for several reasons: to reflect light into the children's faces, to separate two dark colors, and to make the children comfortable.

In this shot, no separation of colors was necessary; the red cars and shirts stand out vividly against the green grass.

INTRODUCTION

distortion emphasizes a movement or creates a striking image, using an extrawide lens (such as 28mm) occasionally can be exciting.

To put it simply, *dare to make mistakes*! It is hard to think of any rule in photography that cannot and should not be broken.

Finally, I hope that studying my photographs—which a critic once called "deceptively simple"—will be useful for your work.

ON BEING A PRO

When I call you a pro, I don't necessarily mean that you are making a great deal of money, or even that you are always taking pictures. You may have accumulated enough knowledge about photography and have produced so much good work that you deserve to be called a professional. (There is nothing wrong with the word "amateur"—it means that you love your work. I hope that you will never stop loving

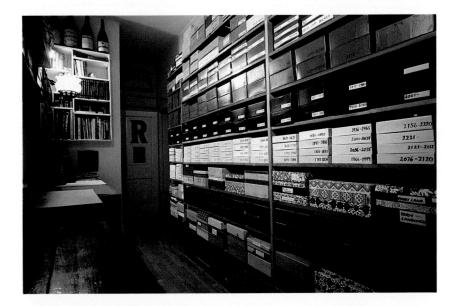

Keeping my files in order by assignment and stock subject is a must; keeping them color-coordinated is a hobby.

photography.) Let's suppose, though, that you are a fulltime photographer. You may take pictures of children in your studio or living room, one after the other, or you may be out there trying to land another advertising account. Is this the kind of life that will help or even permit you to become an excellent photographer?

Doing so won't be easy unless you decide to set aside some time to shoot for yourself, to follow up on an intriguing or beautiful child you have met as a customer or on the bus. A tired mind will not produce fresh ideas for picture stories, and a tired body will not bother to try another way of lighting a picture. An important rule: don't get too tired. You may not have even noticed that you are tired, which can feel like being bored. Of course, the two can be related. If you have only enough energy to keep repeating your usual pictures, you will get bored. But if you do interesting, well-paced work, you won't get tired.

Surprise yourself! Change your lenses, try new angles, use more closeups, and get that new zoom lens out from the bottom of your camera bag where it has been hiding for many months.

Surprise your subjects! Instead of being a worried, preoccupied photographer, be a witty, carefree person, one who is a pleasure to be with. So what if the flash wasn't connected when you started to shoot or if for a while you were doing completely unplanned work.

I suppose this varies somewhat with every photographer, but, in fact, you will spend much less time than you might think actually taking pictures—and much more on getting jobs or clients; talking on the phone; working in the darkroom; and doing your filing, numbering, and general office work. Believe me: unless you have trained a full-time person to know your pictures as well as you do and pay him or her accordingly, you must do all the tasks I have mentioned.

As a reward, you will get to know your own work. You can then not only learn from your mistakes and gauge your progress, but also build up a stock file, or write and illustrate articles, and put together a collection of photographs for a book—all of which I have done during my career as a photographer.

Now if only someone would make it easier to handle original color transparency files, I would have no complaints. What are your current choices? To send out original transparencies, trusting that people will handle them carefully and not lose them, or to have copies made? Unfortunately, these are rarely satisfactory. and most clients say, "We want to use your work. But send us the original right away." (I have also tried making my own copies. What a job! And they are no better than what a good lab can do.)

When you have done 2,474 jobs (my total as of yesterday!), you must have a way of quickly finding each and every negative, transparency, contact print, and enlargement. Luckily, I became interested in working out a simple system early, and it has never failed me. Let me explain it.

Each job gets a number, starting with "1"; it may consist of a single roll of a portrait or of 100 rolls of a child growing up. Suppose that you have just completed job number 225. This is what you will write on a simple list: 255 July '86 Maria Parson and family, incl. new puppy. The number goes on all black-andwhite negatives, contact prints, and prints as well as the transparencies filed in sheets, each of which contains 20 shots. Parts of a job are not filed together; each goes into

37 EAST 63 ST	Г.
NEW YORK, NY	

Photo Release

For valuable consideration and the sum of \$ _______, I hereby give my permission to _______, taken by Suzanne Szasz of me and/or my child/children named: _________, taken by Suzanne Szasz of me and/or my child/children named: _________, for the following purpose: _________, No names will be mentioned. _________, Signed: __________, parent ________, Address: _________, parent _______, PleASE FILL OUT MARKED PARTS, THEN SIGN AND RETURN BOTH COPIES!

its own box or file drawer, in numerical order. The transparency numbering will look like this: 255 1–4, which means roll 1, frame 4.

My system requires one more item: a Rolodex file with the subject's name and address and the all-important job number (here, 255) marked in red. So, if you remember the name "Parson," you will find the number right away. In less than three minutes, everything connected with job number 255 can be on your desk. If you forget the name "Parson," you have to go by the year the pictures were taken. Because each page of the list is marked with the corresponding year, going

through two or three years of photos won't take very long either.

As you can see from the pictures of my files, I help myself by covering my Kodak paper boxes with adhesive paper of various colors and designs, each with a different meaning. For example, red boxes contain color transparencies; green, paper prints; white, contact prints; and flowery design, clippings.

I store all of these boxes on shelves in a room that is automatically air-conditioned for

Tip: Try to sell a once-ayear photography contract to parents.

INTRODUCTION

My friends' children and grandchildren make valuable amateur models.

When I see that children enjoy being photographed, I shoot them again and again.

Whatever my main aim or assignment, I always watch for the warm, unplanned scene.

two hours in the middle of each day. Unless I am working in there, I draw the curtains to guard against the light. These conditions should extend the life of my work.

Order and beauty seem to make office work easier for me. My file folders sport different colors and have big pockets. I keep copies of bills sent out in a red folder, copies of correspondence in a gray one. When I receive paid bills from customers, I place the bills in a blue folder; I can then work on putting them into a permanent file whenever I find some "spare" time. I do the same for prints that are returned to me: I put them into an 8×10 or an 11 \times 14 large box marked "To File." Once a month or so. I file them in numerical order. (I don't want to overwhelm you, but I also have a folder marked "Idea File" and another labelled "To Enlarge for Portfolio.")

Now to an even more important item: releases, or 'How to avoid trouble with the people you photograph.' Suppose I meet a mother with a beautiful baby in the local supermarket, and we agree that I will come to her home and take some pictures. What next? I don't have the gall to present this unsuspecting mother with one of those airtight, "lawyer-invented" model releases. We agreed that I will submit these pictures to magazines, textbooks, or other noncontroversial outlets and that I will ask her for a release when necessary. At that time. I write my own simple release (see sample), pay her a small model fee, and try to get her a clipping if at all possible. I will then have made a friend. I often locate these subjects years after having taken the pictures. If I include them in a book of my own, I send them a copy of the book-not cheap, but fair. Yes, that is the important word: fair. I consider taking pictures

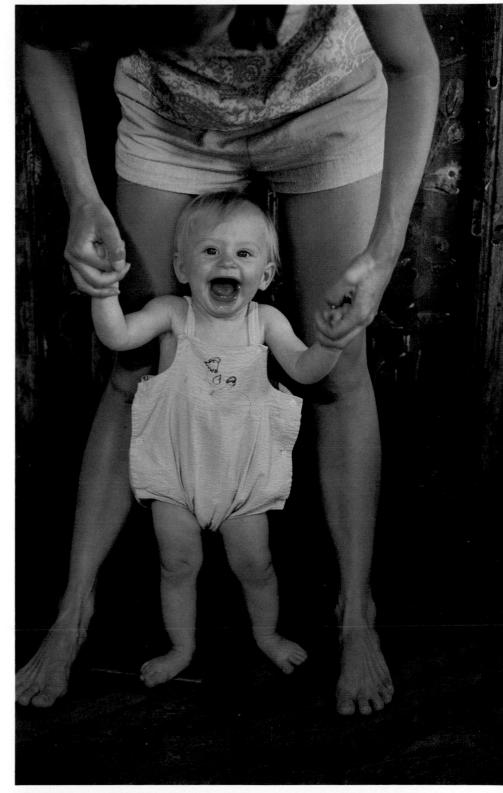

Whenever I see a child who is learning to walk, I take as many shots as I can. I already had this photograph of Christie in my files when an ad agency requested this exact situation.

Tip: When selling stock shots for advertising, charge as much as for an assignment. You save the client time and expense by having the needed shot ready.

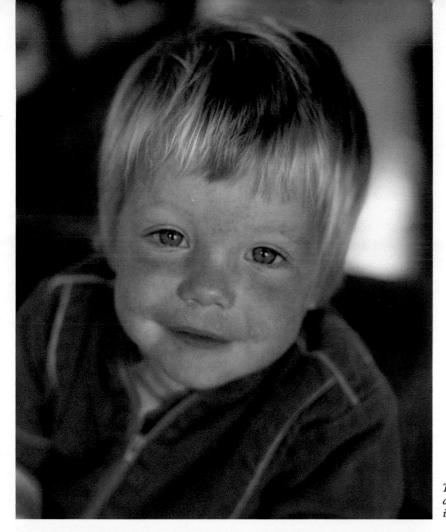

The dream of all private customers: an angelic smile on the face of their little imp.

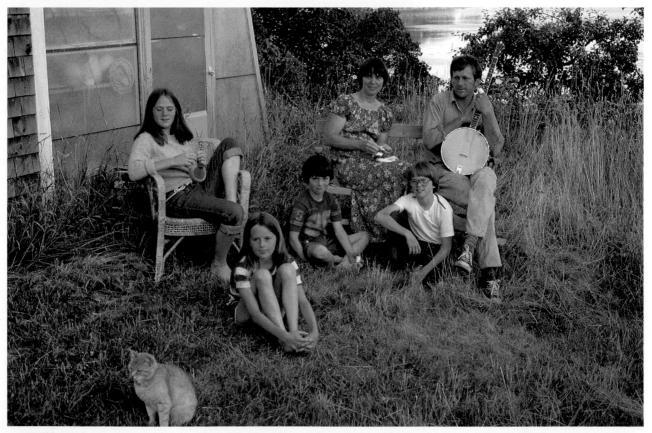

A posed but relaxed shot of a family whose life I had been chronicling in Maine. Their attention was focused on their cat instead of me.

a joint venture and have never regretted the amount of effort and money that goes into my method.

ONE IMPORTANT NOTE: I do want to emphasize, however, that this is simply my own personal method. I strongly suggest that, at the very least, you obtain a copy of the American Society of Magazine Photographers (ASMP) guidelines for releases. (Contact ASMP at 205 Lexington Ave., New York, NY 10016.)

THE HELP YOU NEED

Some photographers may need to supplement their income either by printing for others or by taking part-time jobs that leave them enough time and energy for their own work. I know of photographers who worked as parttime book editors, teachers' helpers, camera store salespeople, writers, and even tennis instructors while on their way to becoming full-time photographers.

Once I was established, and although I consider myself a one-person operation, at different times in my career I had the help of several people and organizations. When most of my work was black-andwhite, I needed a printer. Since I didn't have enough work for a full-time helper, I solved the problem by offering the use of my darkroom to a person who would print for me once or twice a week. That left making exhibition prints and enlargements for my own books to me, which is the way I like it.

Tip: Instead of suggesting ideas and outlines, try to approach a magazine editor with a finished story. This can be a simple set of pictures, but it should have a beginning, a middle, and an end; it should also be suitable for that particular publication. In the beginning, I was surprised to find that reps wanted to work with photographers who were already making respectable sums of money. "We can more than double your moncy," they promised. I opted for visiting art directors and editors on my own and have never been sorry. I think it was time well spent on learning their opinions and requirements. I do, however, know of other photographers whose careers blossomed after a rep had assisted in developing the direction of their work.

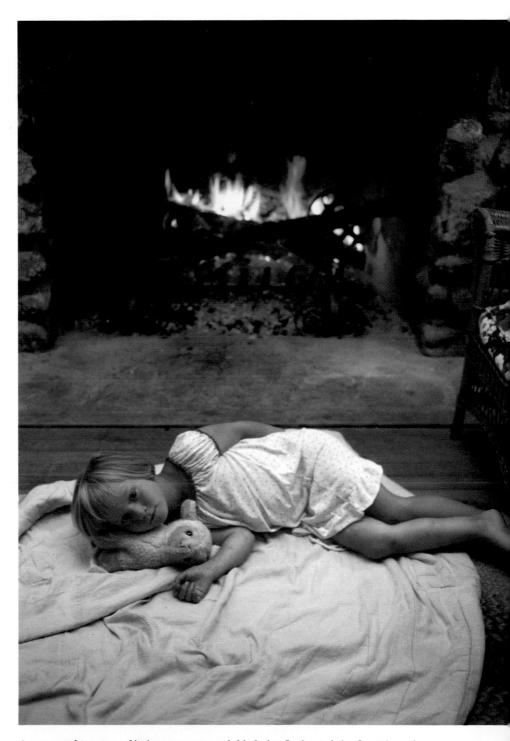

A rare combination of light sources: available light, flash, and the fire. The colors may not be faithful, but the atmosphere is.

INTRODUCTION

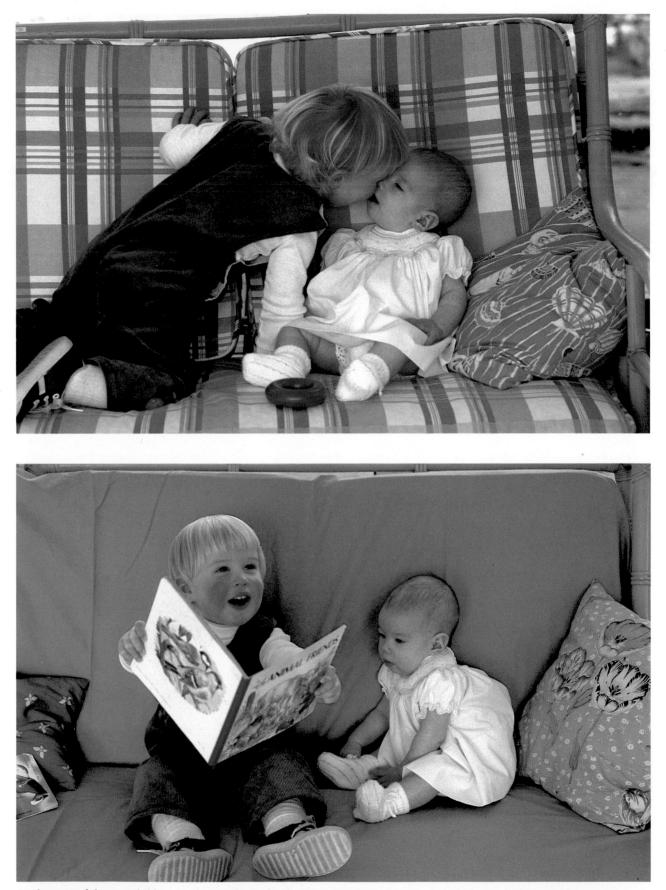

In the case of the two children on the couch, the loud pattern kept bothering me: I could barely find the children's faces because there were so many lines. I then draped a plain sheet over the couch. When the children returned, I found the background much more pleasing.

About 15 years ago, I met the people who comprise the Photo Researchers agency. I like and respect them, and we have never had arguments about money, even when we happened to contribute to the same book. (Editors or researchers came and bought from my files; they also bought work of mine that was in the agency's files.)

It is not the agency's fault that I am having problems with surrendering the originals of my best color work to its files, and clients dislike dupes. I do try to take more than one original of the same situation—but children rarely hold still (unlike landscapes or posed subjects).

Throughout my career, I have valued the help that ASMP has given me. Not only is it instructive to listen to the best people in our field explain some aspects of their work, it is enjoyable to meet your colleagues on a regular basis. And it is important to feel that you are not alone when you fight for more money and all rights to your pictures.

Another group, American Picture Professionals (APP), also holds monthly meetings where you can meet not only photographers, but also others working in the publishing field.

A few years ago, some of us founded Professional Women Photographers (PWP) in order to share our knowledge and experience with women just starting out. At some of the gatherings of this group, I was able to meet women whose names and work had long been familiar to me.

Finally, I would like to mention two books that can be of great help. Selling Your Photography (New York: St. Martin's Press, 1986) deals with all the various aspects of the business side of photography. Its authors are Arie Kopelman and Ted Crawford. The other book, Professional Business Practices in Photography (New York: ASMP, 1986), is an excellent compilation of such matters as sample agreements, release forms, and ways of settling disputes.

Tip: Be sure that your photographs include both sexes, all ages, and a good mix of races if you want to sell to textbook publishers.

Textbook publishers often ask for stock pictures and are glad when you have just what they need.

TECHNICAL BASICS

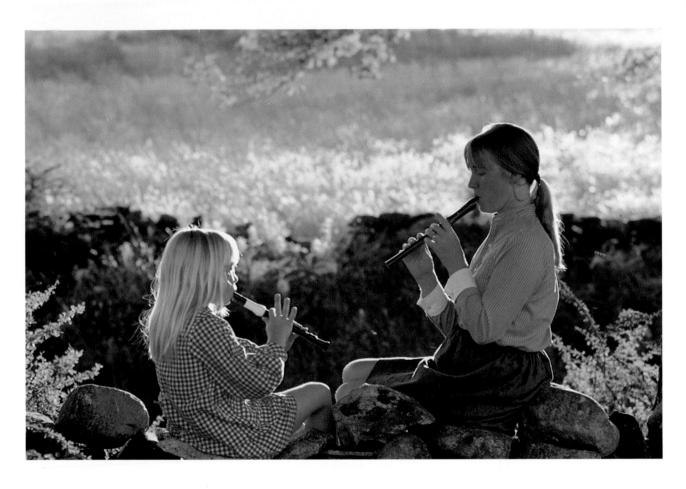

I have been looking in vain for an example of a color picture taken with the sun behind me. I didn't think I would have to shoot one especially for this book: all of you have seen them already. People are likely to squint or wear dark glasses; the colors lack subtlety. With very few exceptions, all such photographs look amateurish to me. That's why I have grown so accustomed to shooting against the sun. This is not easy on my eyes, but it is comfortable for the people I photograph.

Sunlight looks magical when it hits the outline of a figure or a child's blond head. But sunlight can also fool you as well as automatic cameras since only a small part of the picture is touched by the sunlight. As a result, you need to increase the exposure so that everything in the shade is also properly lit.

I took this photograph of a mother and daughter playing

their recorders for a Creative Playthings Brochure. I chose the spot for the picture carefully. I knew that I would not need any fill-in as there was another patch of well-lit grass behind me, which helped to lighten the figures. I opened up one stop, then two stops more than the overall metering indicated. I finished the roll in this manner while enjoying the duets my subjects played.

WHEN THE SUN SHINES

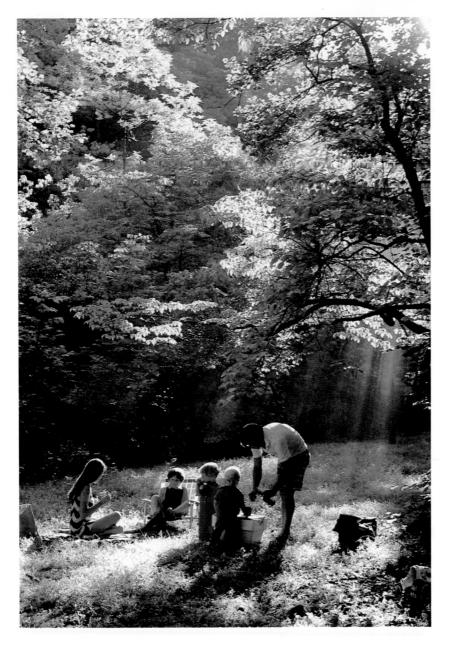

Sunlight can come from the front, back or side; its effect also depends on the angle of the sun. Each season changes the angle, as does the time of day. Photographs taken in the morning have a cool, bluish look; late in the afternoon, you notice a warm tone. This is determined by the angle at which sunlight passes through the different layers of the atmosphere. As the sun goes down, its rays can produce magic. A little clearing in the woods of Maryland, a picnicking family, and beautiful backlit trees are the ingredients that make this picture one of my favorites. I tend to prefer photographs of mine that "just happened." This is not because I don't like to work, but because "accidental" photographs somehow feel more authentic.

I watched this little girl as she happily practiced her newly acquired skill of walk-

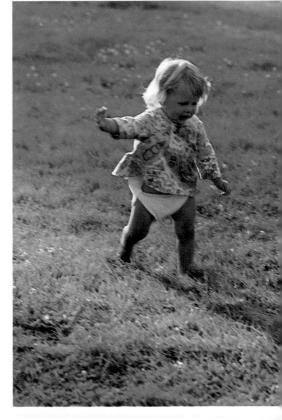

ing. This is the best of the shots I caught, backlit by the sun and frontlit by the sunny patch of lawn in the foreground. (I don't know how this picture escaped having an overall green tinge.)

Of course, *I had to be there*. That is the one most indispensable element of any picture. You have to invest your time, really enjoy working with people, be there from start to finish, and take advantage of any lucky break.

FILLING IN AGAINST THE SUN

When you work near sand. light pavement, or a sunlit wall, you can take advantage of the way each lightens the shaded parts of the picture. In this photograph, practically every blade of grass shimmers and the two little girls stand out against the greenery as if lit by special spotlights. No fill-in was necessary; the sand at the children's feet provides that. But you cannot always depend on finding foregrounds or natural reflectors that eliminate the need for artificial fill-ins. As a result, you should be prepared with a good small electronic flash, which can be used either directly or bounced off a white card.

How much fill-in you need depends on the strength of the

sunlight, the distance between you and your subject, and the power of your electronic flash unit. When you shoot directly, you can figure out your *f*-stops using tables and your instruction booklet.

I suggest that you make your own tests, too. Start by taking an overall meter reading of a backlit subject and add fill without making any adjustment in the exposure. Then advance a few feet and shoot again. Next, return to your original spot and after stepping back a few feet, shoot again. Now bracket by both opening and closing your lens one f-stop each time. It not only sounds complicated, it is. Therefore, keep a completely accurate record of all your shots: film type, speed, fstop, distance from subject, and camera model. Be sure to ask your film lab to give you back your developed roll uncut; then you can keep comparing each shot to the corresponding data on your record.

After you choose the best five or six shots, have them framed at the lab, and then record all information on the cardboard frame. Here is an example: Kodachrome 64, 1/60 sec. at *f*/11, from 5 feet away, Minolta 320 electronic flash at full power.

Remember, you must use 1/60 sec.—unless you have one of the new cameras that allow you to synchronize your flash at 1/100 sec. or 1/250 sec. And, yes, even automatic electronic flashes should be tested.

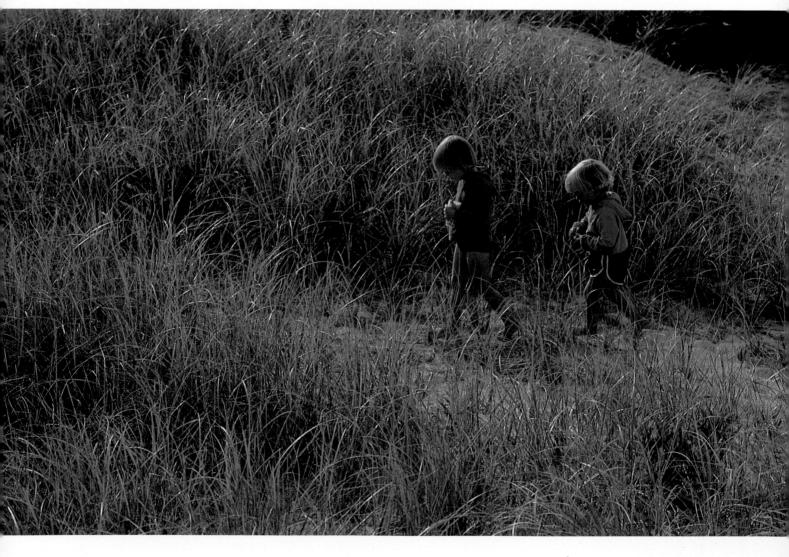

WITHOUT SUN

This is not an easy section for me to write because the subject matter is so simple and natural: avoiding harsh direct lighting, aiming instead for soft, even illumination. I have photographed instinctively this way from the day I started out.

I wonder. Doesn't everyone think that not using cumbersome equipment whenever possible makes sense? Hasn't everyone noticed that the meter reading is nearly identical whether the sun is shining or is hidden behind white clouds? And isn't the world of children especially suited to be portrayed in pastel tones?

If so, do I need to discuss the convenience and beauty of shooting without sunshine? But, more than that, I am urging you to dash out to hunt for wonderful pictures when you notice that the sky is cloudy.

That's exactly what I did when I asked a friend if I could spend some time with her three-year-old daughter. The little girl was in her tree house, playing with her teddy bear. I love the results: two little round heads framed in a larger circle.

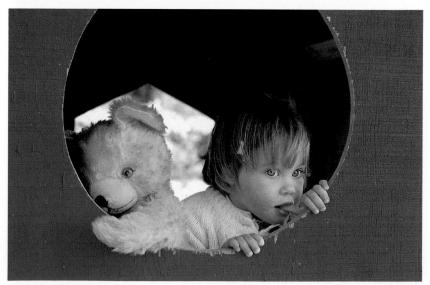

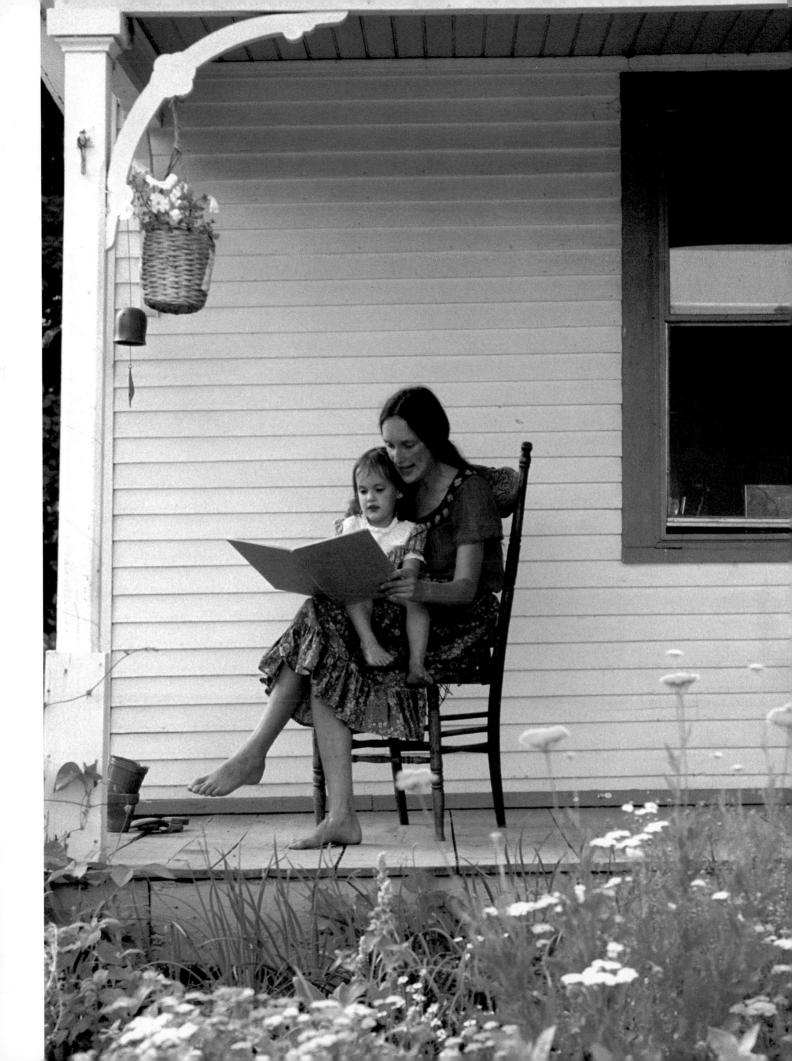

WITHOUT SUN

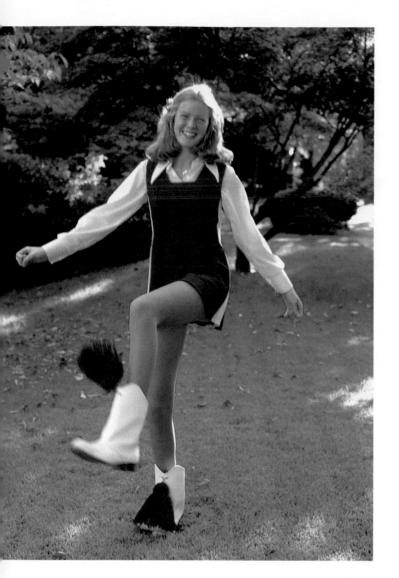

I wouldn't dream of doing a book that did not include the picture on the opposite page: it is one of my favorites. It has already been used in two of my earlier books. This was not an easy picture to take because there were about 100 guests walking to an outdoor wedding. It took a great deal of jockeying on my part to isolate my friend and her young daughter from the crowd.

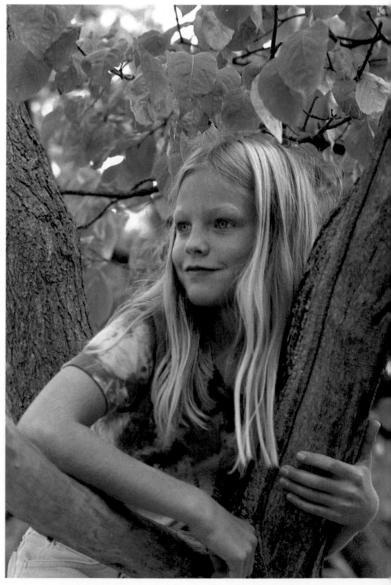

On another day, Sonja, whom I have known since she was a baby, wanted to demonstrate her cheerleading talents to me; I asked her to dance on the shady part of the lawn. In this picture, she moved into one of the small patches of direct sun coming through the trees. When you examine how different the lawn looks where the sun changes its color, you can imagine the unpleasant effect the sun would have had if it had lit Sonja's face.

I like to encourage the children I photograph to ask a friend to come along with us. This way they can talk and play and forget about me and my camera. Sophie was showing her tree climbing ability to a friend when I caught her with a 100mm lens.

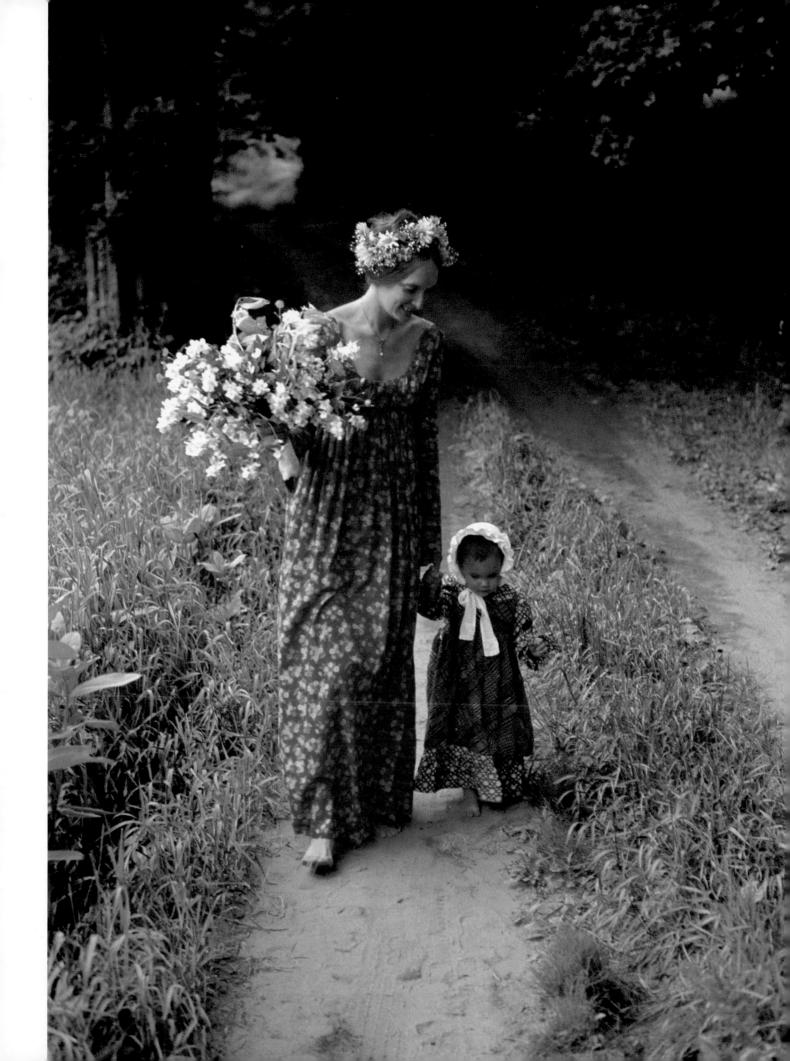

AVAILABLE LIGHT INDOORS

I think that these pictures help to explain the advantages of being ready to shoot at a moment's notice. Whatever the light, the situations are so unexpected and interesting that you simply have to take a chance. Advertising your presence will immediately change and ruin whatever you like about the scene; this rules out using flash unless you are willing to settle for only one shot.

The little girl is emptying her mother's dresser drawer. I am sure she would never have done this had she not been left alone in the bedroom after I took some photographs of her there learning to tie her shoes.

It is important to let life just happen by removing yourself from a scene after a while. When you come back, you will see what the children really felt like doing.

A final point about this shot: I set the 35mm lens at 1/30 sec. at f/4, which is not recommended for an action shot, I know; but the result justifies having taken the chance.

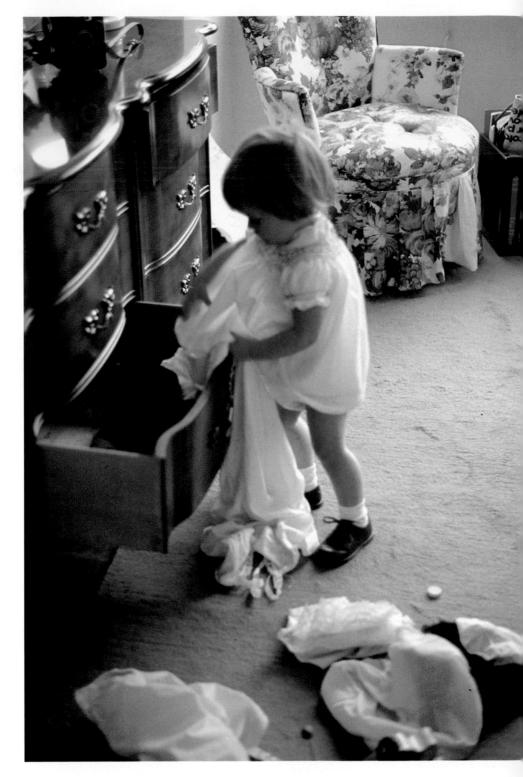

When I walked into this Maine kitchen, I saw that Joshua and his mother were having an important discussion. I had no lighting problems as there were windows on all sides. Knowing I had to draw the line between catching the moment and eavesdropping, I took just two or three shots with an 85mm lens. I then left and let mother and son finish their talk.

It is not unusual to want to

see and hear everything. But I believe that children deserve privacy, too, and I can justify my intrusion only by believing that I contribute by recording their emotional lives.

I once left two photographs out of one of my books because my nine-year-old subject, who had been in the bathtub, protested. The boy's mother didn't mind, but we both thought it was important not to embarrass her son.

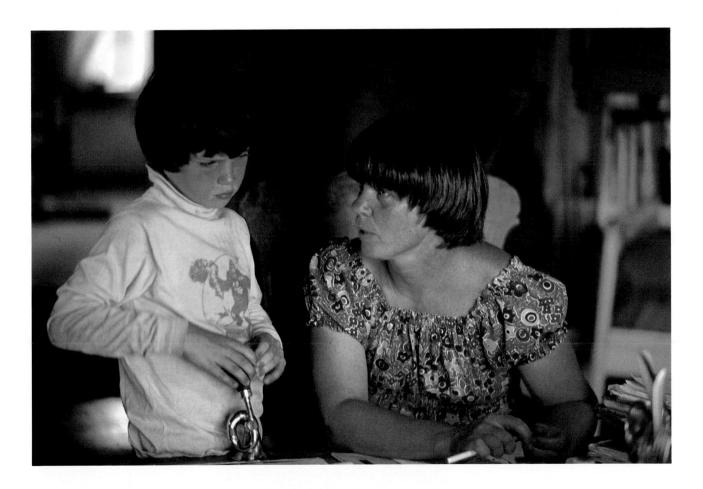

AVAILABLE LIGHT INDOORS

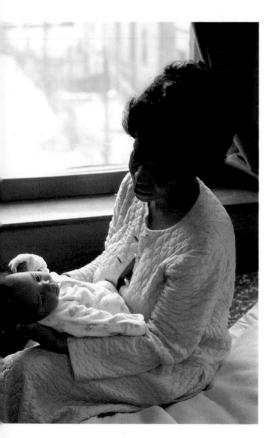

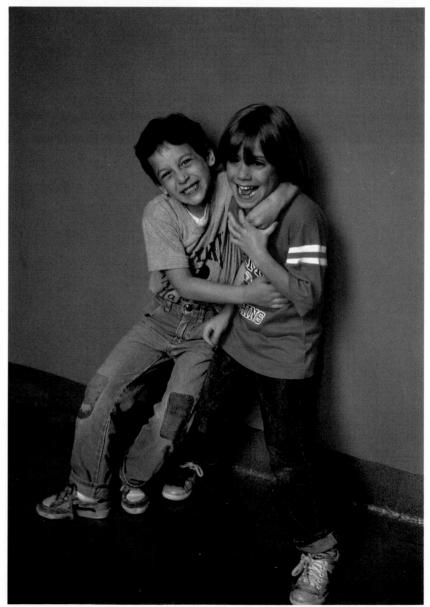

Each picture has its own little story, of course: a new knit hat or a favorite red shirt that the girls are happy to show off, a friendly tussle in a school corridor, a quiet moment as a mother watches her haby fall asleep in her lap, and the difficult time a teenager has trying to write a thank-you note at the kitchen table.

These are all scenes of everyday life that I was able to capture by using available light. I concentrated on what was happening, and allowed life to unfold without my direction. I believe that this approach will help you take really good photographs of children.

To put it simply, I wish I could always work with available light. With it I can fulfill my aims as a photographer. I want people to share what I see when a four-day-old infant smiles back at hcr mother. I also want people to understand that their children can feel pain and joy and express a range of emotions so fleetingly that sometimes everyone is surprised when the camera catches them.

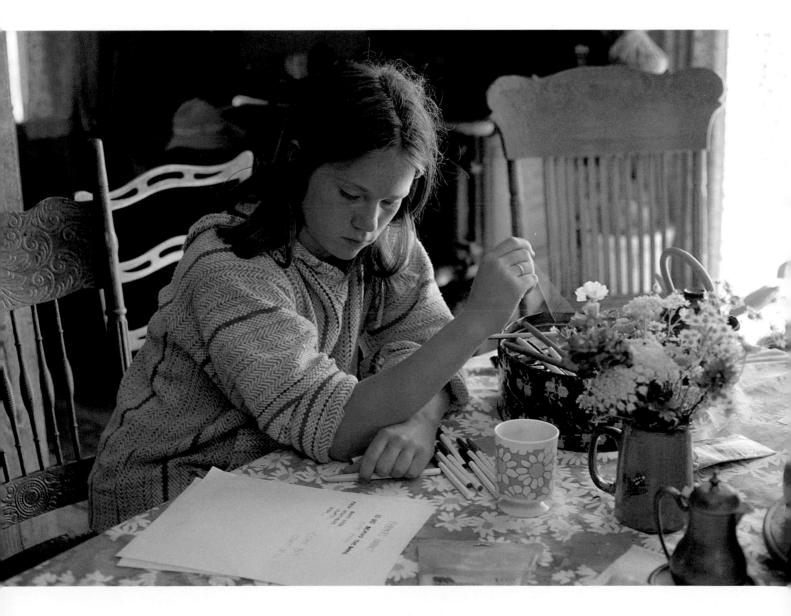

DIRECT FLASH

It would be pretentious on my part to suggest that I know all the ins and outs of direct-flash photography. I shied away from it when I started, and I only use this method of lighting pictures when nothing else will work. In most large halls, such as school gyms, it would be hard to think of any other way to take pictures in the evening.

I admit that there are many advantages to direct-flash photography. Even a small flash unit produces good pictures when used direct; it stops fast action. And with automatic units you don't even have to worry about the exposure.

But once you start using an electronic flash, you will find it difficult if not impossible to keep your subjects from noticing what you're doing. Also, the closer your subjects are to the background, the more noticeable the shadows will be. Only experience will teach you how to minimize them.

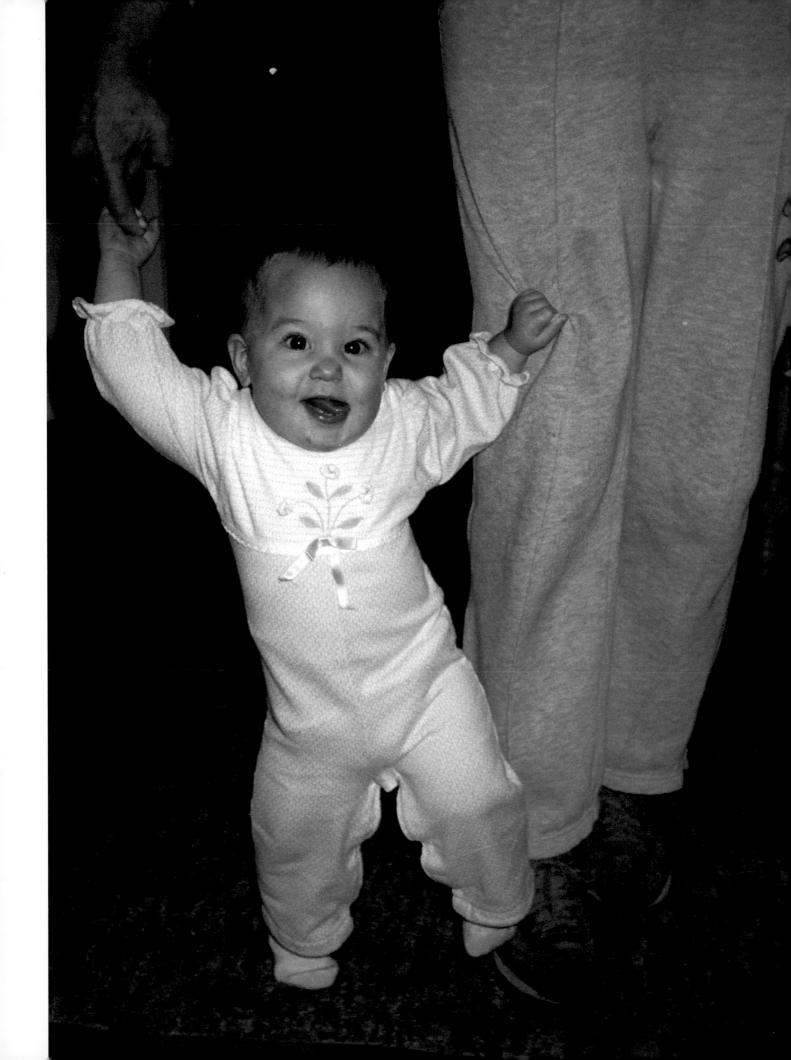

DIRECT FLASH

As do all other methods, direct-flash photography has its applications. This can be seen in the work of both Jill Freedman and Weegee. Maybe *you* will utilize direct flash in children's pictures better than anyone else ever has.

As for technique: read your manual, and then read it again. And remember whether or not your unit is automatic—make your own tests, as I discussed earlier.

BOUNCE FLASH

Hurray for small but powerful electronic flash units that swivel on a camera or lightstand and bounce light off ceilings or walls. After some trial and error, most of your pictures will look as if they were illuminated by available light.

But I must warn you: it is very hard to predict exactly how the height of the ceiling or another reflecting surface will affect the colors in your photograph. Only lengthy experience will give you the know-how to shoot within two stops of the correct exposure. After a while, you will walk into a room, notice the color of the walls, look up, estimate the height of the ceiling, and think, "That's an f/4 ceiling."

Today, automatic flash units let you take a test shot, and if you guess correctly, a little green (or red) "OK" light goes on for a few seconds.

If you have to shoot in a room with a ceiling that is very high and/or dark, you can save your photos by mounting your electronic flash on the stem of a white umbrella. (I must admit that I use this setup only when I have an assistant who carries my gear and makes sure no child bumps into the lightstand to which the umbrella is attached.) Now you won't have to guess and take test shots: you will know what exposure your particular flash and umbrella require.

This is a wonderful way to work when taking posed shots—but attention-getting and not very mobile. Getting really candid shots is hard when your camera is connected to a flash that is mounted on a lightstand . . . on top of which sits an umbrella . . . all steadied by an assistant. . . .

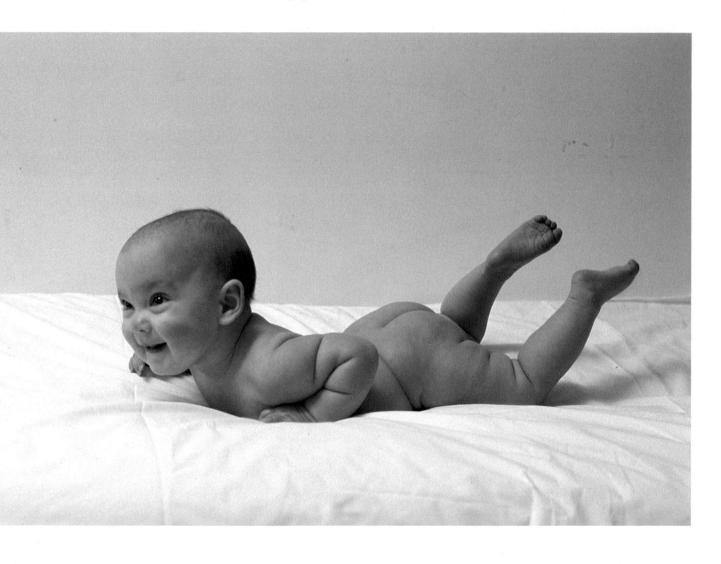

For this mother-child picture, using an umbrella was possible because the baby was still; I would not, however, have been able to set up in time to catch the little girls in the picture on the right, who were trying to go out the door.

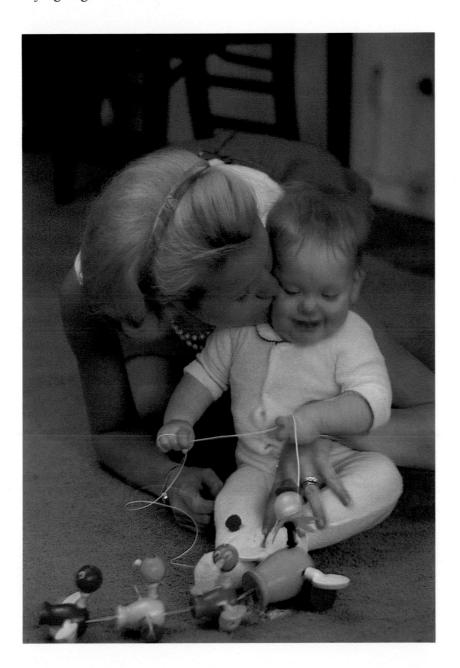

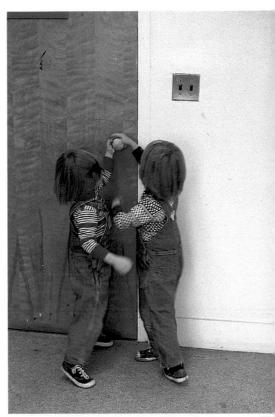

BOUNCE FLASH

Now, some technical information about bounce flash. It is not easy to deal with such complex electronic wonders as the automatic flash unit when you want to fill in the shaded areas. I prefer to use my electronic flash on the manual setting, which allows me better control of the fill-in.

As usual, I make several tests, writing down exactly what I do (later I make sure that the lab returns my roll uncut). First I change my output control from full to 1/2, then to 1/4. Next, I vary the distance from subject to electronic flash and shoot some tests at different *f*-stops. Then I weaken the fill-in by resetting the flash's film speed indicator to a higher ISO. And, finally, there is the old-fashioned method of putting a diffuser on the flash head, all in manual mode.

You can also try one of the newest (and simplest) methods: placing a plain white 4×6 card behind your flash. If you are handy, add some Velcro to both the flash and the card so you can put on and take off the card easily. A couple of rubber bands can also do the job. When the flash head is pointed straight up, this card will "directbounce" some of the light onto your subject. In the picture at the bottom of the opposite page, you can even see 'catch lights" in the child's eyes.

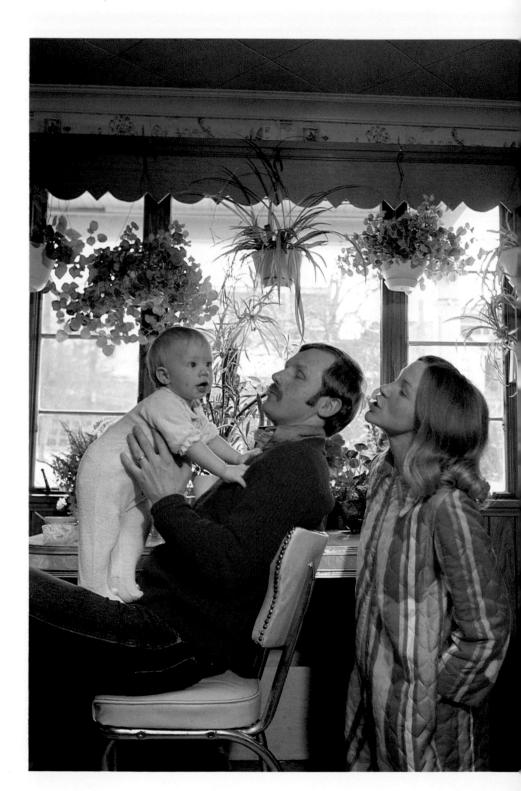

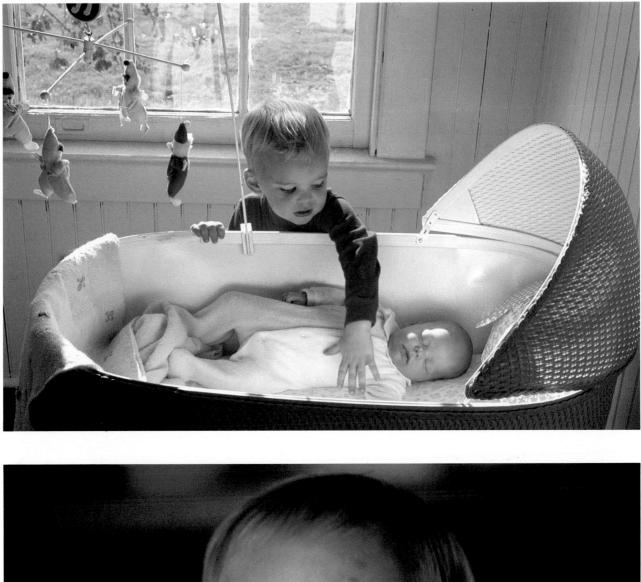

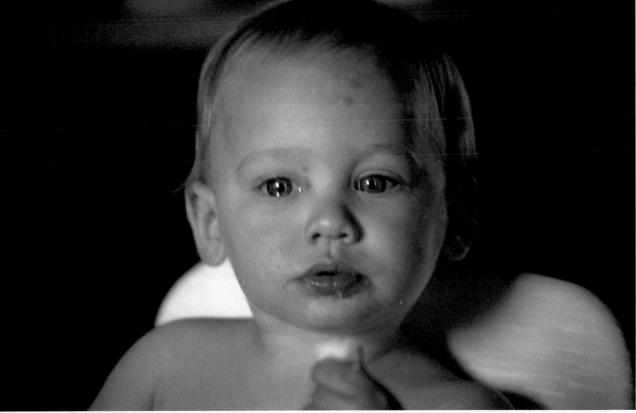

TUNGSTEN LIGHTS

I would not be surprised if many of you have never used tungsten lights and film or even heard much about them. (In this section any reference to floods or reflector floods means tungsten light, designed to be used with tungsten-balanced film.)

When I started out, working in black and white, I usually augmented available light by clamping a photoflood to a bookcase or shelf or by putting one light on a stand. I was then set to shoot anywhere in the room. People's eyes quickly got used to the increased illumination, and I felt that no one knew when I was taking my pictures.

Except in rooms with very dark walls and very high and/ or dark ceilings, I was able to bounce my lights off the ceiling or walls. This gave me lighting so natural that I have trouble determining if I had augmented the available light.

When I started to work in color. I discovered that photofloods also came in blue to complement light for daylight-balanced color film. So for a long time I carried the necessary reflectors (blue photofloods don't come in the compact mushroom shape). Then one day I must have accidentally used tungsten photofloods to fill in on daylight film. The resulting pictures were warmer in tone than usual; whites especially tended to be yellowish. But in many cases, the golden light was quite pleasant, particularly when the needed fill-in was not strong. This has remained an option in my shooting ever since.

A third alternative is using tungsten-balanced film with tungsten lights. This is fine for late afternoon or evening or for rooms without windows, as tungsten film registers the daylight coming in from outside as an odd shade of blue.

Tungsten lights are wonderful when you are learning to improve your backgrounds. You can *see* how to adjust your lights in order to eliminate a disturbing element in a background. This will serve you well when you want to use electronic flash (when you cannot see the light you will eventually get).

It is easy to light up a room so that you can take pictures from most angles. All you need to do is to secure two 500-watt reflector floods in opposite corners of the room. If the ceiling is a typical low, white surface, you can bounce the lights off it; if not, use them directly. A word of caution: you *must* be sure that the wires are secured in such a way that the children cannot reach them and possibly hurt themselves.

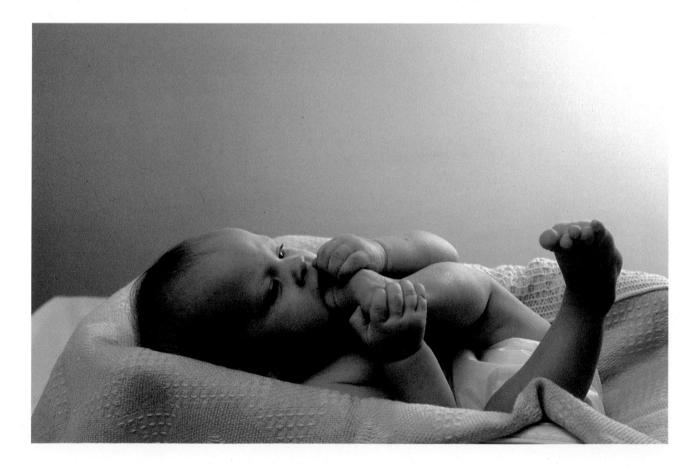

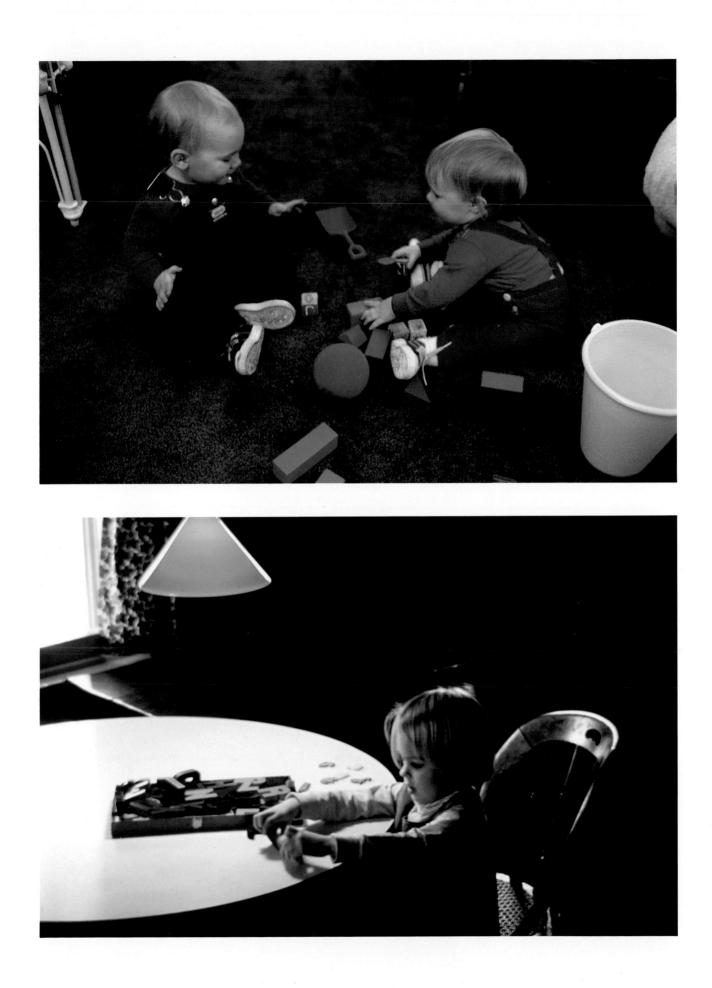

TUNGSTEN LIGHTS

In the picture on the right, some fluorescent light was also present in the classroom.

In the picture below, I had one direct photoflood in the back, another direct light in the front—and the father standing by to make sure that no one got tangled in the wires. Never try such a setup without an assistant or with other children in the room; it is too dangerous. (I have never had an accident with my lights, but I am always very careful.)

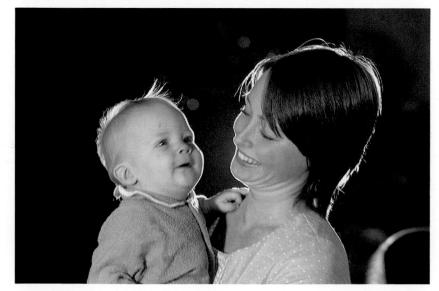

In the photo on this page, the little blonde girl was posed in front of the plain white wall in her room. The wall was illuminated by one direct reflector flood. She sat about four feet from the wall: I stood about six feet from her, with a photoflood slightly to my left, aimed directly at her face. Not many children can be trusted to be patient and tolerate the strong light, but I knew that Fairley was delighted to be photographed for a sweater ad.

Although many children are born models, I tend to discourage mothers who are eager for their children to become professionals. I remind them how hard it is for both of them to go from studio to studio, whether their offspring feel like posing that day or not.

I consider my work to be the recording of every facet of childhood. I appreciate my friendship with many families that allow me to use their children as "models" when I have an assignment for a specific shot, be it of a "baby eating" or a "boy riding hobbyhorse." And I don't think that the children are hurt by posing in their own home when they look forward to the toy they are going to get and when the mothers know that they will have a check to put into the children's bank account. Most children also enjoy the attention that accompanies photography. I treat them with my usual patience and appreciate what they contribute to the original idea for the photograph.

No, the photographs of plants and cats you see on these two pages are not included here by mistake. I think that they can be useful when you want to experiment. The best manual will not tell you any more about depth of field or the effect of lenses with varying focal lengths than will going out and seeing the result in your pictures. As Andreas Feininger advises in one of his books, "If you have to say 'Hold still!'---you better photograph flowers that do hold still!

Well, cats don't hold still, nor do they take kindly to being moved from one chair to another, or even being turned to look to the left or right. And you can't ask them to do so. You just have to catch them when the light is good, when they seem to be in the mood to stay where they are, and when they have gotten used to you. Some cats are afraid of the camera—and so are some children. (After all, you "shoot" them, don't you?)

I believe that a person who can record a cat's life will be able to do the same with children. So, if you are contemplating doing a photo project on your own children, you should practice on a cat in order to become an expert on sensing what your subjects may do next and to observe and photograph them quickly and sensitively. You may even catch a yawn! And then, when you start on your project with your children, they will thank you and your results will be much better.

The same tulips taken from the same spot with a 135, 85, 50, and 35mm lens, respectively.

EXERCISES FOR BETTER TECHNIQUE

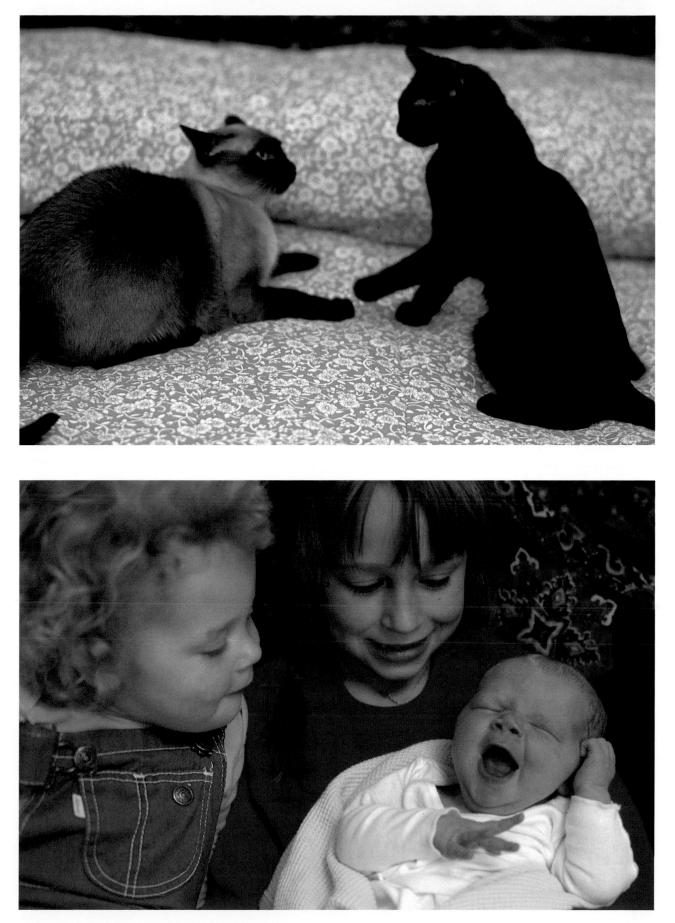

DIFFERENT ANGLES

One of the surest ways to add some freshness to your photographs is to vary your angles. Viewing scenes from ground level or from high above produces a pleasant shock.

I am always aware of stairs, balconies, and second-floor windows because they can introduce a new perspective in a familiar scene. There is a fringe benefit: such vantage points also let me photograph without being noticed. As you can see, what might have been an ordinary photo of a child looking in a mirror is dramatized both by the high point of view and the use of a 35mm lens.

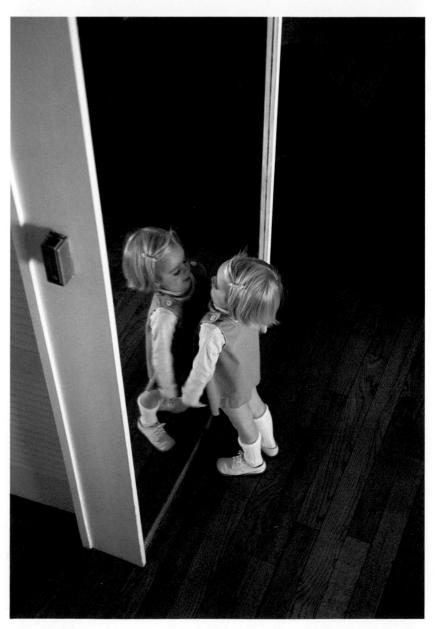

While standing, I could hardly see anything of this baby's face as he lay on the bed. But when I knelt down, I could see his face as well as his body, and the sheet became an important part of the picture.

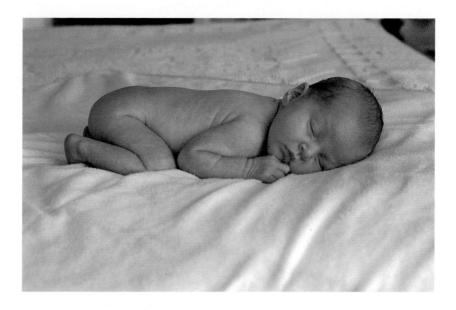

This is another example of a low angle, accompanied by unusual framing: Ira is looking through his father's trouser legs. I was working in a small room and had trouble getting a good picture of the child because someone or something always seemed to be in my way. So I decided to include what I could not ignore. This will often produce a much more lively, realistic shot than will always checking to see if the background or foreground is "clean."

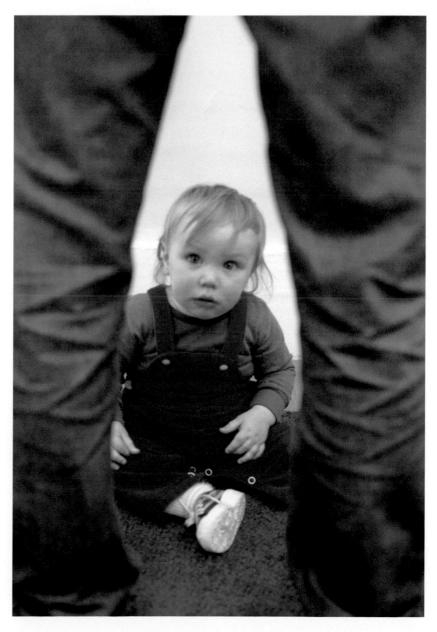

FOREGROUNDS

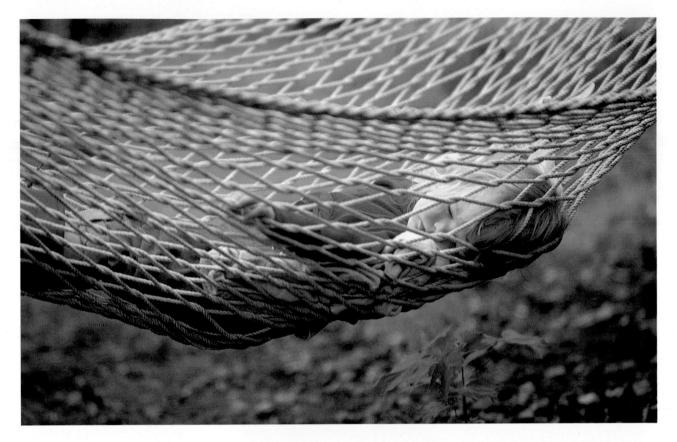

When I saw Maya sleeping in her hammock, I shot several pictures, being careful not to wake her. In the first picture here, I was holding back some branches with my foot in order to get a clear shot of her face. When I let the branches go, I noticed that the greenery added to the feeling of the picture. I kept the foreground blurred, mysterious. "Little blonde Sleeping Beauty in the woods," I thought.

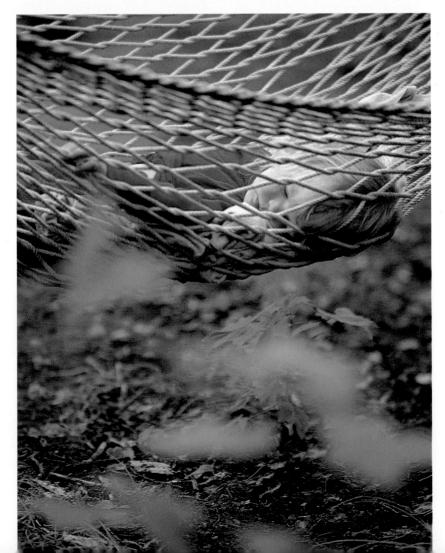

BACKGROUNDS: SUBDUED

There are two ways to handle the background in your pictures: make it count or play it down by blurring it. In either case, this is an important part of your photograph and can make or break it.

You can control your background by choosing a plain surface to shoot against, one whose color blends into the picture harmoniously. If you cannot find such a background, you can create one by adjusting your lens opening.

You know, of course, that the more you stop down the lens, the greater the depth of field is. Conversely, the more you open the diaphragm, the shallower it becomes. With larger openings, the subject stands out beautifully against a soft, blurry background.

Working with wide openings for out of focus backgrounds, you must remember that exact focusing is vital. Exact focusing means that the most important point in the picture should also be the sharpest; for example, in the case of one child, that point should be the eyes.

The color of any background is also influenced by the amount of light that hits it directly. Unless you aim a light straight at a white wall, it will go gray. Even strong colors can lose their vibrancy if they are not lit adequately.

The focal length of the lens also influences the background in photographs. Long lenses are ideal for blurring the background; wide-angle lenses, for making it sharp and crisp.

The picture in the garden was shot with a 50mm lens, from a distance of three feet, 1/125 sec. at f/2.8.

For the photo of the boy and his dog, I used a 100mm lens, from a distance of six feet, 1/250 sec. at f/2.

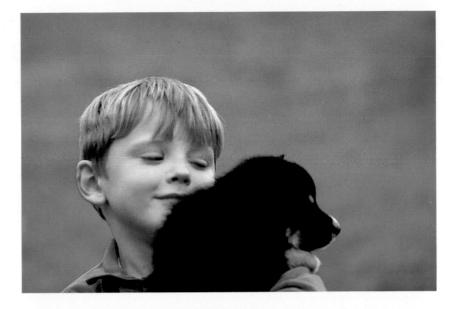

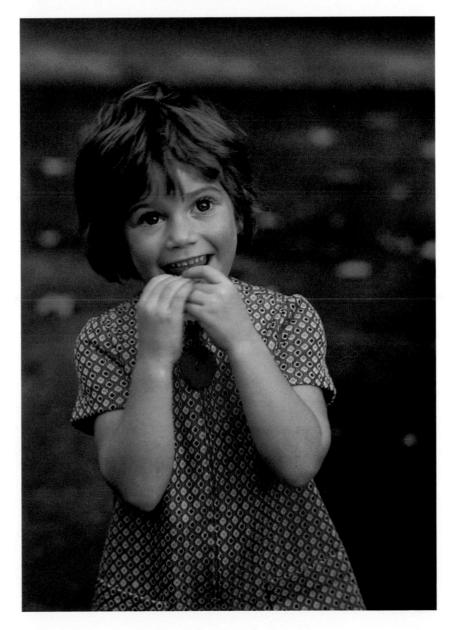

BACKGROUNDS: EMPHASIZED

In these four pictures, I wanted to show the background as clearly as possible. It is the background that sets the stage for the children, giving information about where they are. Obviously, I shot the first two pictures in a big city; the other two, in the country. The city pictures were taken with a 50mm lens, the country photographs with a 35mm lens. In all four photos, I closed the lens down to *f*/8 and focused on the children.

In the case of travel pictures, you will want to make sure you choose the exposure that will show both the background and foreground clearly.

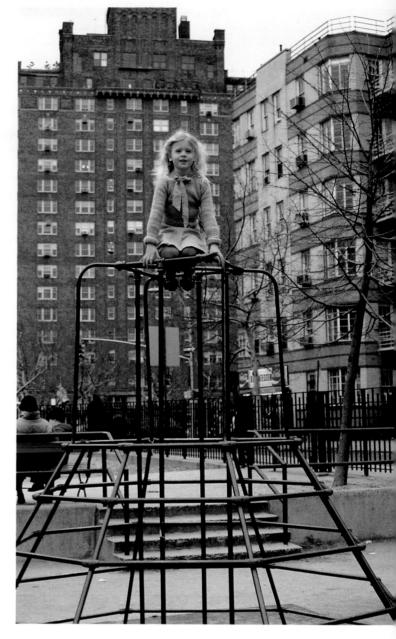

In the photograph of a mother and daughter at the piano, you get a feeling for the atmosphere of their home. Had I been assigned to show the charming antique furniture in detail, I would have had to use additional lighting.

Whenever I evaluate my students in a seminar, I usually end up talking mostly about the way they handle the background in their photographs. I find that they often ignore how it affects their subjects, not only by letting a telegraph pole "grow" out of a

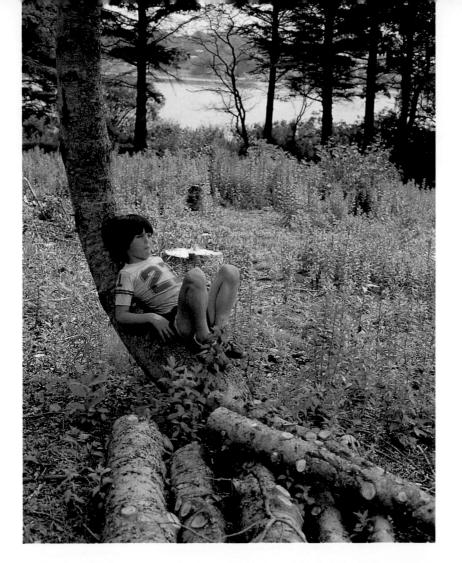

person's head, but also by letting their automatic cameras overemphasize a light background.

My students often fail to use some beautiful element of a landscape to give added meaning to a picture and disregard how the color of the background will affect the foreground.

This is why it is so important to pay careful attention to these points and to be aware of the *f*-stop you are shooting at. Your photographs can improve dramatically if you do.

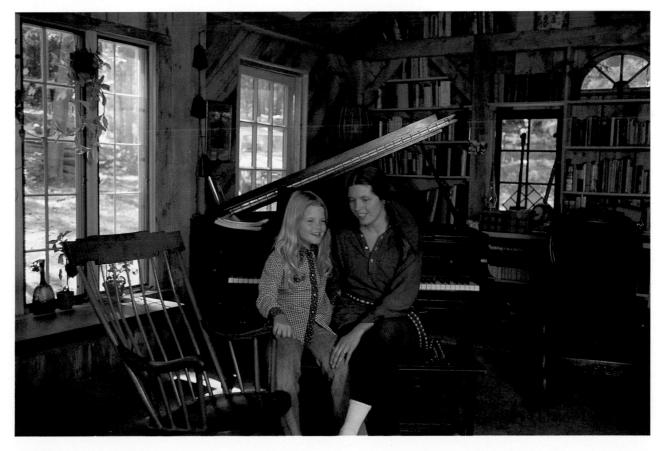

PUTTING THE BASICS INTO PRACTICE

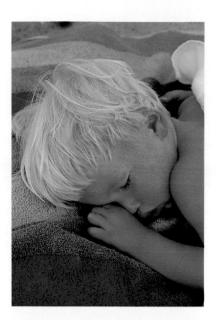

It sounds simplistic but it's true: when you spend time with children, they provide you with one interesting photo challenge after another.

Children are interesting whatever they do; even when eating and drinking (with enthusiasm or reluctance), they look charming. But that is not all. I believe that photographers document all aspects of people's lives, particularly their habits and feelings. For this reason, the simplest everyday photograph may be and often is wanted to illustrate, for example, societal changes, dress habits, or important psychological traits. The photographs in this section show that there are female doctors, that boys wear their hair long in the '80s, and that children can help with lawn work and with preparing muffins.

Small points, to be sure; but from many small points the larger picture emerges: the picture of life around you, which you reinforce with your photography.

(I would like to reiterate my feelings about noting the camera setting and lighting of most of my photographs. About 90 percent of my pictures are taken in very simple ways, and I would be guessing

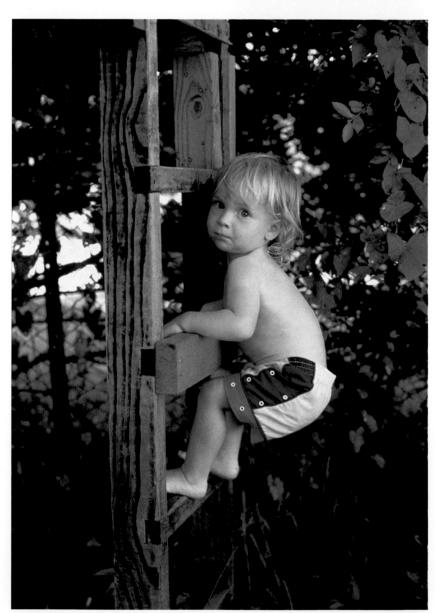

THE EVERYDAY WORLD

if I tried to give you the exact camera setting in every case. This would also be boring because I took so many of the photographs at 1/100 sec. or 1/60 sec. at f/4, f/5.6, or f/8. This is not one of my quirks; it is sort of an ideal compromise between enough depth of field and fast enough speed that allows me to produce the sharpest picture possible in different situations. It is true, though, that the situations are not that diverse. I rarely talk about photographing athletic feats that need very short exposures or large groups that need lots of depth of fieldsuch as f/8 to f/16. (As I said before, if I used unusual or peculiar exposures, I will mention them.)

I strongly recommend that you get used to photographing in shade. The exposure is closer to that of shooting against the sun than you may think, and the colors glow in a special way. You won't get faces with one side appearing pink and the other brown, depending on where the sun hits, or "average" exposures with automatic cameras unable to bridge the gap.

The photo of the little girl drinking orange juice is a good example of using sunlight properly. By walking around Jane until I found an angle at which the background stayed in the shade and making sure that my exposure was taken from her face, I was able to highlight the juice. After all, I was photographing a child drinking her juice.

The picture of Christopher raking the lawn is a semisilhouette. His body stands out against the background, showing action and enthusiasm. In order to maintain some accurate color in his face and body, I had to overexpose the lawn; shooting from the opposite side would have resulted in better greens, but a less expressive action photo.

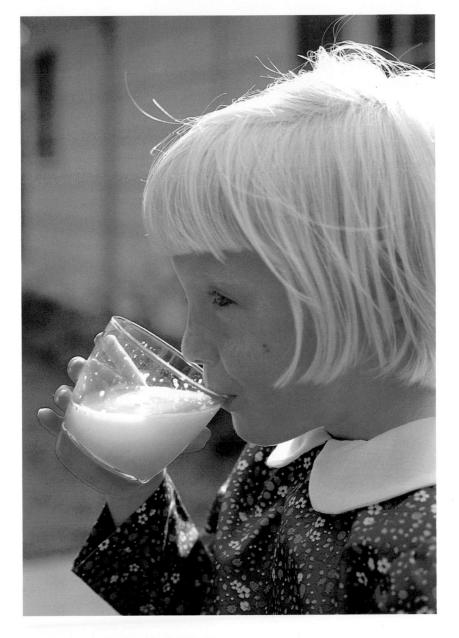

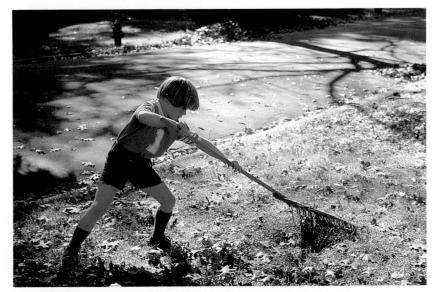

THE EVERYDAY WORLD

The three photographs on this page were all shot indoors, with available light, on Ektachrome ISO 200. I believe the exposure was 1/30 sec. at f/4. I am often tempted to use ISO 400 or even faster film, which would let me shoot at 1/60 sec. or even 1/100 sec. (at the same f-stops I usually use). But I have found a difference when it comes to enlarging, projecting, or reproducing these transparencies: more grain, less sharpness.

I followed Peter's mother as she went to wake him up and I saw him, framed by the crib's bars, looking hopeful and adorable. I found Emilia getting dressed by herself. Not many photographers would start their day looking for such everyday occurrences. Still, with very little or no additional light, it is possible to catch these typical scenes of family life.

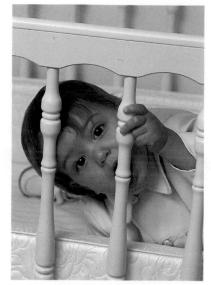

The simple solution to this problem is to add some portable light; in the case of these two photographs, I used a small automatic electronic flash, bounced from the ceiling. Bathrooms are especially suitable for this method; they are usually small and white and add two f-stops to the exposure. But beware! Only a few cameras will synchronize at faster than 1/60 sec. We are now back at my favorite exposure of 1/60 sec. at f/5.6. (See more on fill-in flash on page 22.)

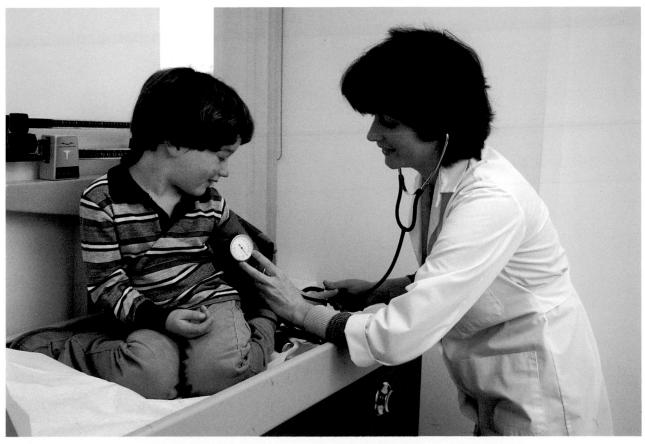

THE EVERYDAY WORLD

Of all my photographs, I like those best that have a certain quality of happy accident and intimacy. The longer I plan what I want, the more I lose these qualities. Instead, I like to take advantage of even the smallest incident. In the two photographs on this page, both mothers greeted me with apologies that they weren't ready yet; one child insisted on taking a bath, and the other was still in bed with a cold. The mothers were surprised that I welcomed these situations and felt that they would produce interesting pictures.

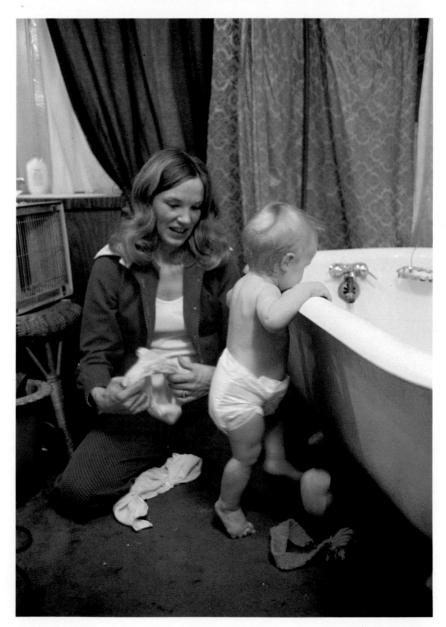

Here are two photographs that show how I use photofloods. I love floods because I can shoot without the interruption of flashing lights and can see what I will get. In the first picture, I used one photoflood on a stand near me, bounced from the ceiling and Ektachrome ISO 160 tungsten-balanced film. The second picture was a bit more tricky. I used daylight film but emphasized the background by clamping a flood on a convenient shelf.

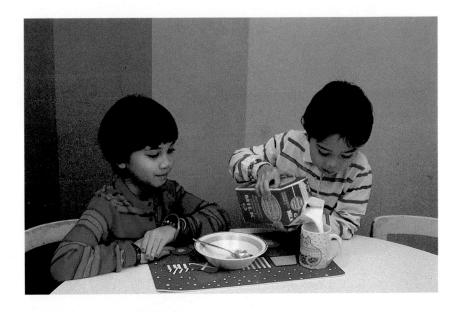

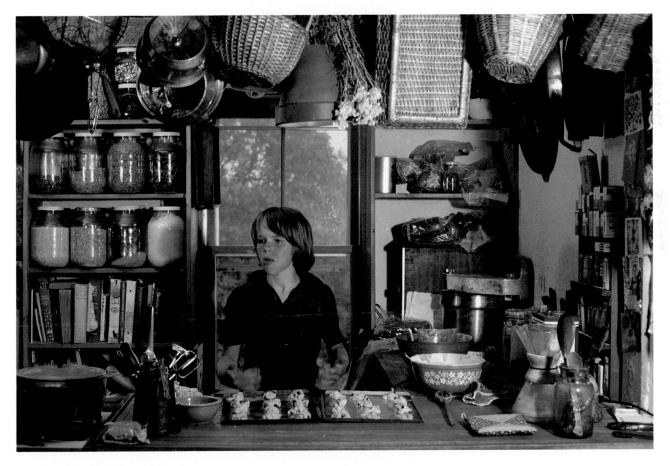

COLOR AND CONTENT

Obviously, a fine color photograph will owe its excellence to both its content and the beauty of its colors. But you rarely encounter the best of both worlds, and generally either content or artistic color will predominate.

Sometimes color can spoil an otherwise excellent picture. Some subjects cry out for somber colors and subdued light. Imagine a scene of a very poor, forlorn child wearing a torn, bright orange dress, shot against a clear blue sky. Between the gaiety of the colors and the sadness of the child, you get conflicting messages.

You could blame the photographer's taste: the colors seem to trivialize the content. But what can the photographer do other than not take the picture? He or she cannot control the color of the subject's dress nor make the sky turn gray by wishing it. If the photographer is able to change position, the sky could be eliminated and the pavement could become the background.

Sometimes luck is with me. The little girl in this picture used paint exactly the same color as her dress. Her evident dedication to her task contributes to the satisfying feeling the photograph evokes.

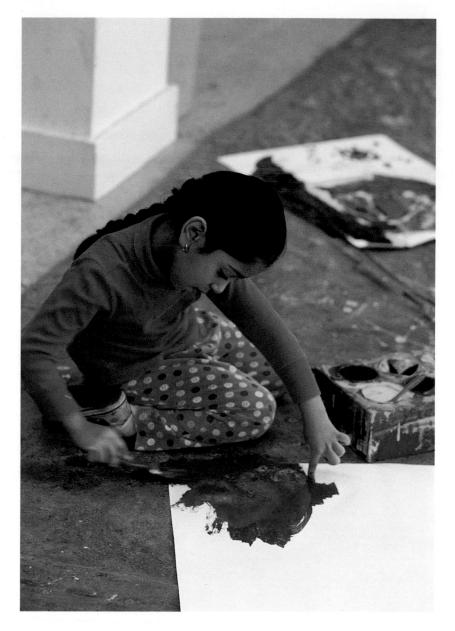

This picture of a little boy sucking his thumb was taken at a beach. The late afternoon sun produced the lovely, warm skin tones; here, the colors enhance the value. Sometimes you have so little time to take a picture that you almost have to shoot without a thought to improving it. This quarrel erupted so quickly and the teachers were so close, ready to intervene, that I barely got this one shot. The overflowing emotion of the two children gives this picture its value.

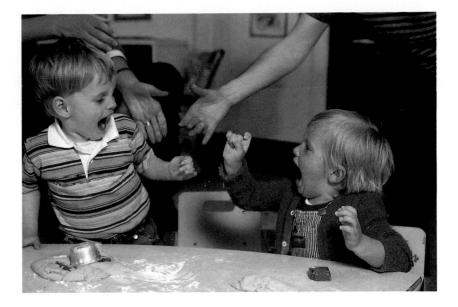

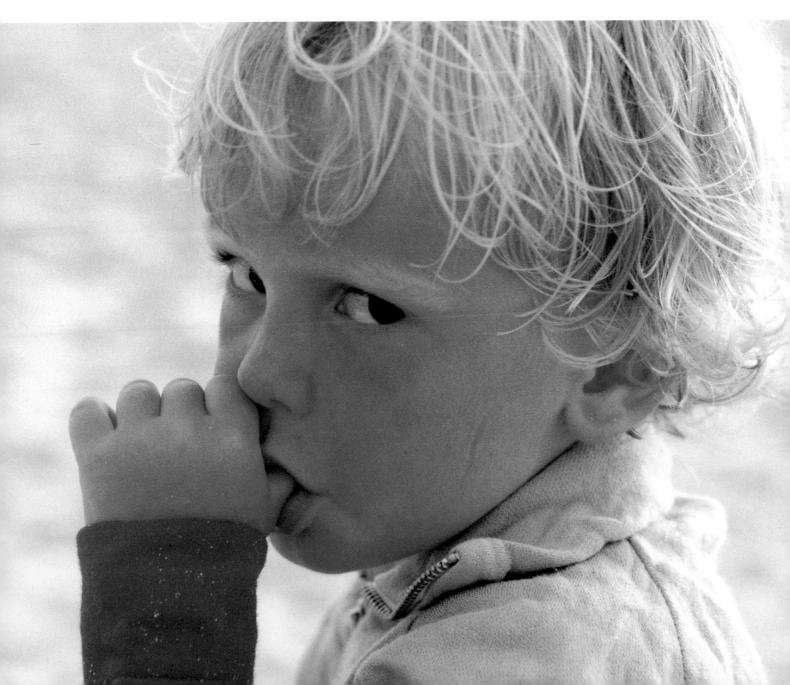

COLOR AND CONTENT

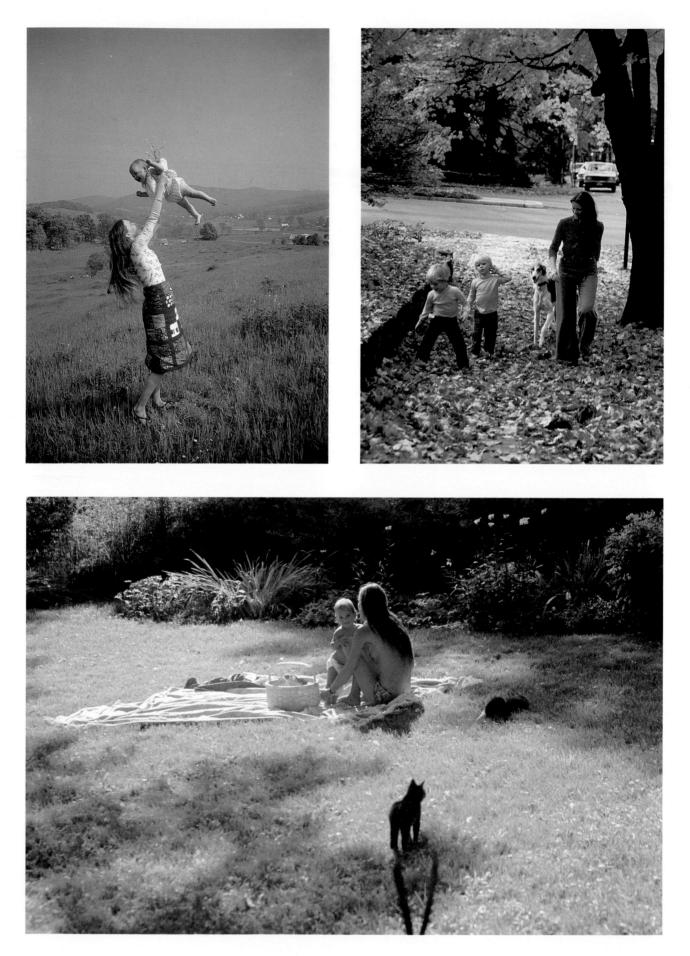

Here are three photographs of mothers and children enjoying the outdoors. What would nature be without green meadows, golden leaves, and blue skies? No black-andwhite film could match color here. The colors seem to echo the subjects' enjoyment of breathing fresh air while playing, of having fun with a pet, and of this beauty. A brief note about gilding the lily: when I started to photograph my friend playing with her baby in the Vermont hills, she was wearing a blue denim skirt. After a while, I asked her to tie the baby's quilted red blanket around her waist—a definite improvement.

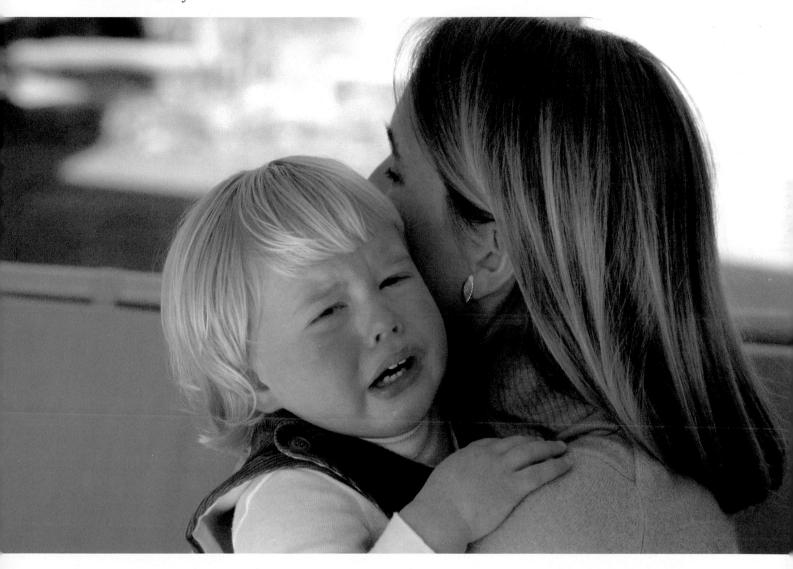

This photograph would be just as good in black and white. I wanted to catch the child's distress. If anything, without the nice colors, the content would become more striking.

COLOR AND CONTENT

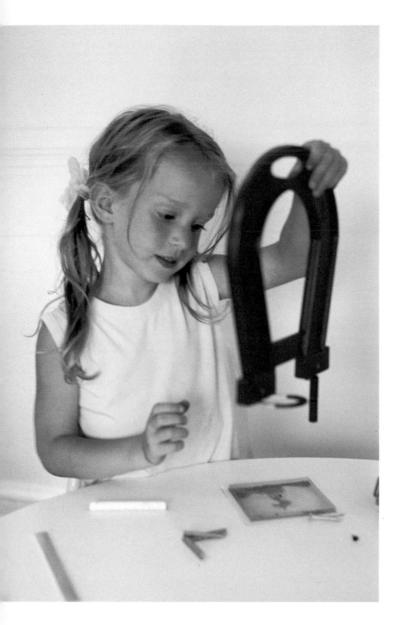

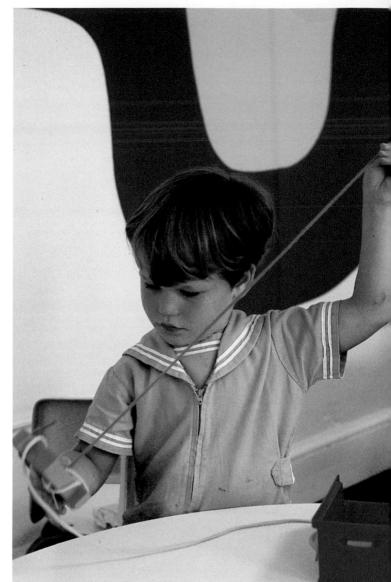

I am tempted to put together the two photographs in which the curve of the big red magnet is repeated in the wall decoration of the nursery school. This color-as-design can keep you from looking at other aspects of the picture, such as whether or not the children are really absorbed in their work, for instance. (I used an 85mm lens so they wouldn't be aware of me.) The color white can look brilliant when lit by enough light, or it can look dark gray, as in the kitchen wall in the background of this photo.

If you have ever observed the color of flowers in a garden at dusk, you will have noticed how colors lose their saturation and become darker and darker.

The picture below is an example of an appropriate background. The sight of falling leaves is melancholy, and these children are not happy.

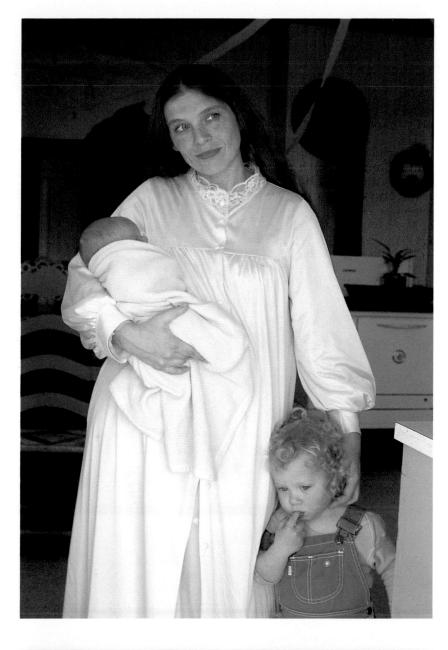

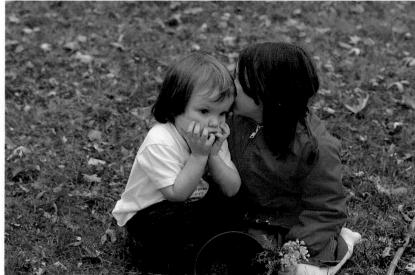

COLOR VERSUS BLACK AND WHITE

What is the difference between black-and-white and color photographs? Do different films have distinct personalities? Are there any rules about when you use one or the other? Hard questions with only tentative answers.

The difference between black-and-white and color photography is that black and white is much less literal than color. Obviously, all photographs are abstractions since, to begin with, they are two-dimensional. And few photographs, except in specialized fields, are the actual size of what is represented. Then, when we translate color into a set of tones ranging from black through gray to white, we have again moved farther away from reality. Thus, through photos we re-experience reality, minus three of its basic characteristics.

As for film itself, it is not so much that each has its own personality, but that photographers choose, for conscious or unconscious reasons, the film that fits their personality.

I rarely feel like taking the very same picture in black and white and color, but with this photo I did. My blackand-white picture of the mother and her two children is the better one, I think. Why did it turn out this way?

In the first few minutes of shooting in black and white, all I concentrated on was the mother-son-baby trio, and I captured something of its psychological possibilities: the older child's tension as he waits to be given his breakfast.

In general, color film makes both the photographer and the viewer concentrate on the outward attributes of a scene. We look at the shiny copper bowl and notice the green leaves of the plants. Thus distracted, the photographer may miss the right instant to click the shutter and show subjects at their most interesting.

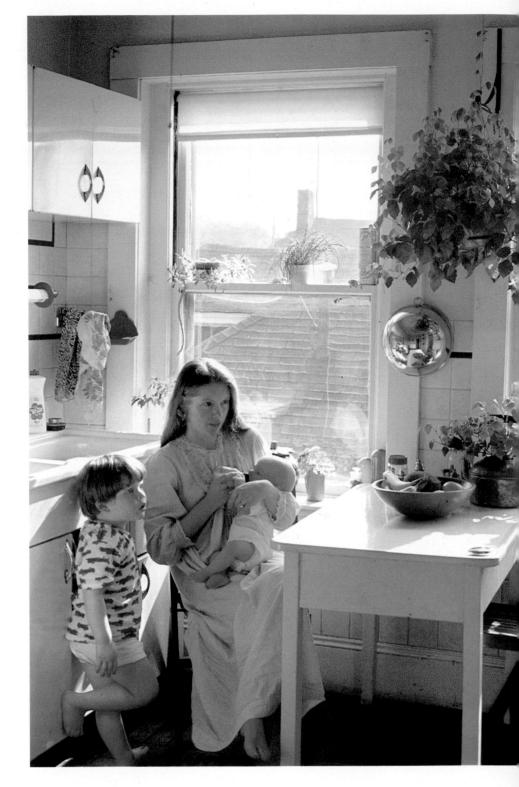

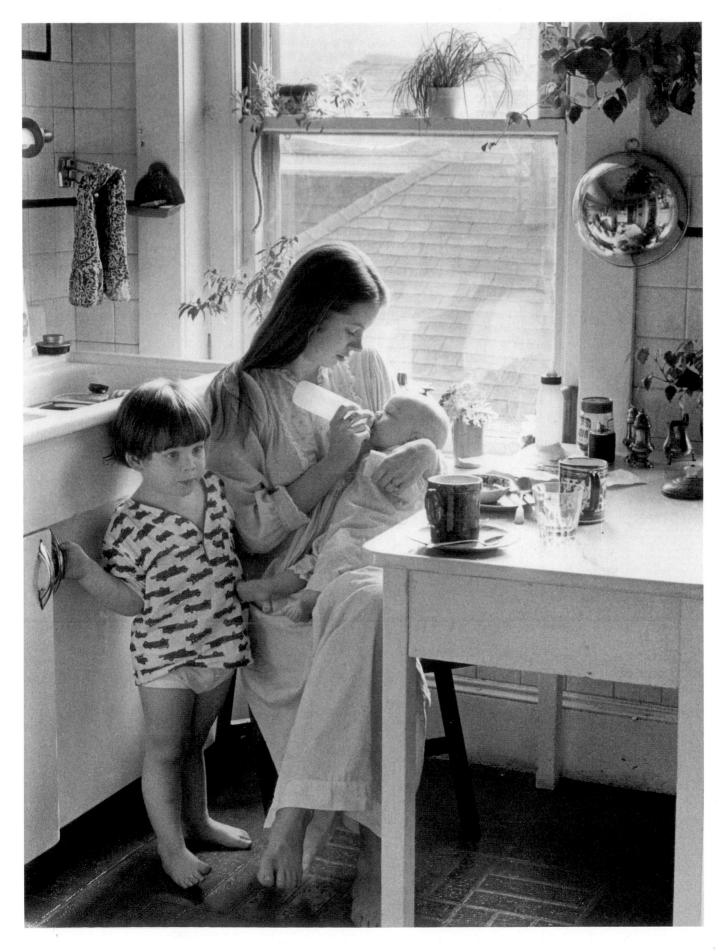

PHOTOGRAPHING IN BLACK AND WHITE

Transforming real life—which has color—into black-andwhite photographs—in which shades of gray represent color—is very exciting. With black and white, you are not forced to choose between color or content; your attention—and, as a result, your camera—is focused on your subject. You feel that, by distancing yourself from reality, you have created something new, something magical. You also learn a lot by handling black and white. Developing; making contact prints; and learning to wash, dry, number, enlarge, crop, and mount: all this is eliminated when you entrust most of this work to a lab, as is done with color transparencies. As a result, I somehow feel that I know my black-and-white photographs much better than I do my little color transparencies. I have also found that parents really appreciate a good black-and-white portrait or action shot of their children; they rarely can produce one themselves.

A final point: museums still show mostly black-and-white prints. It is much more rare to find color photography—now the accepted medium for magazines, television, and advertising—accepted as art.

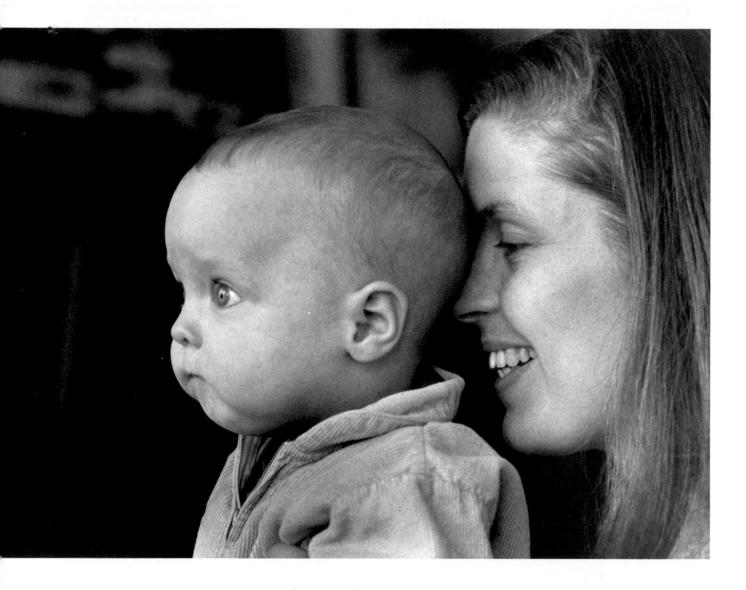

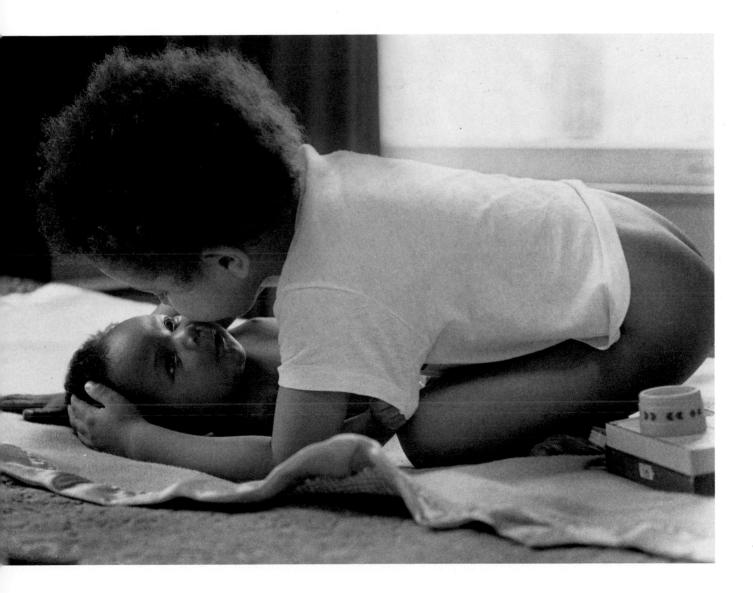

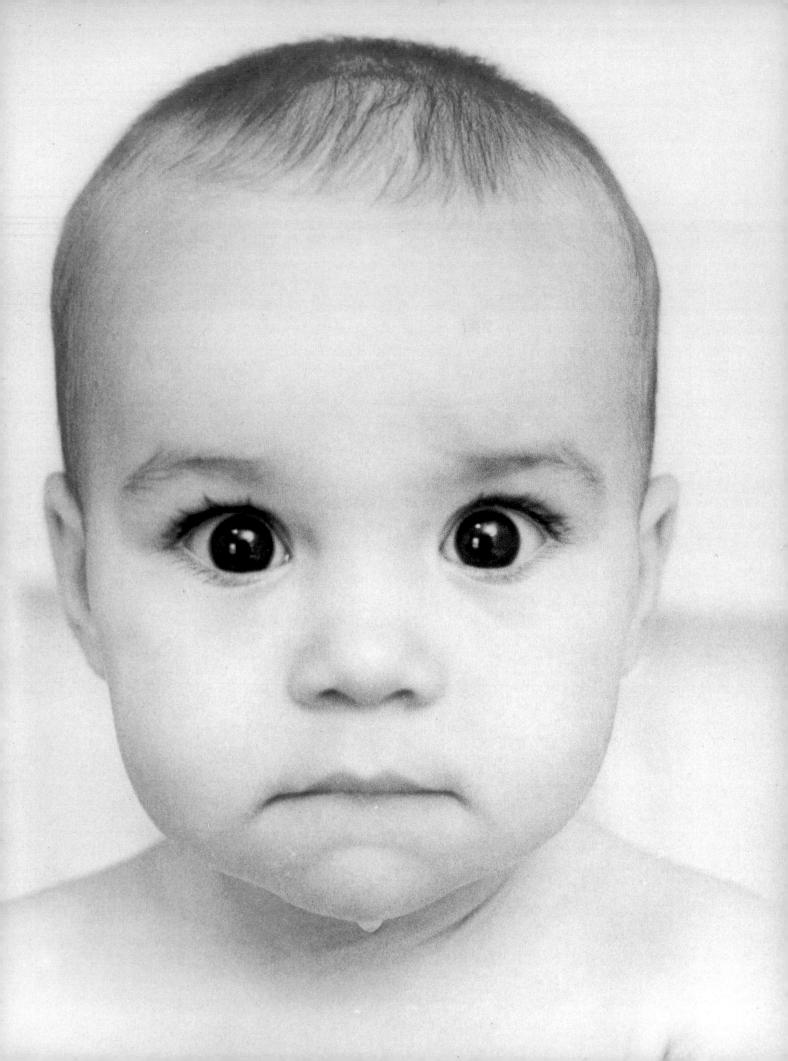

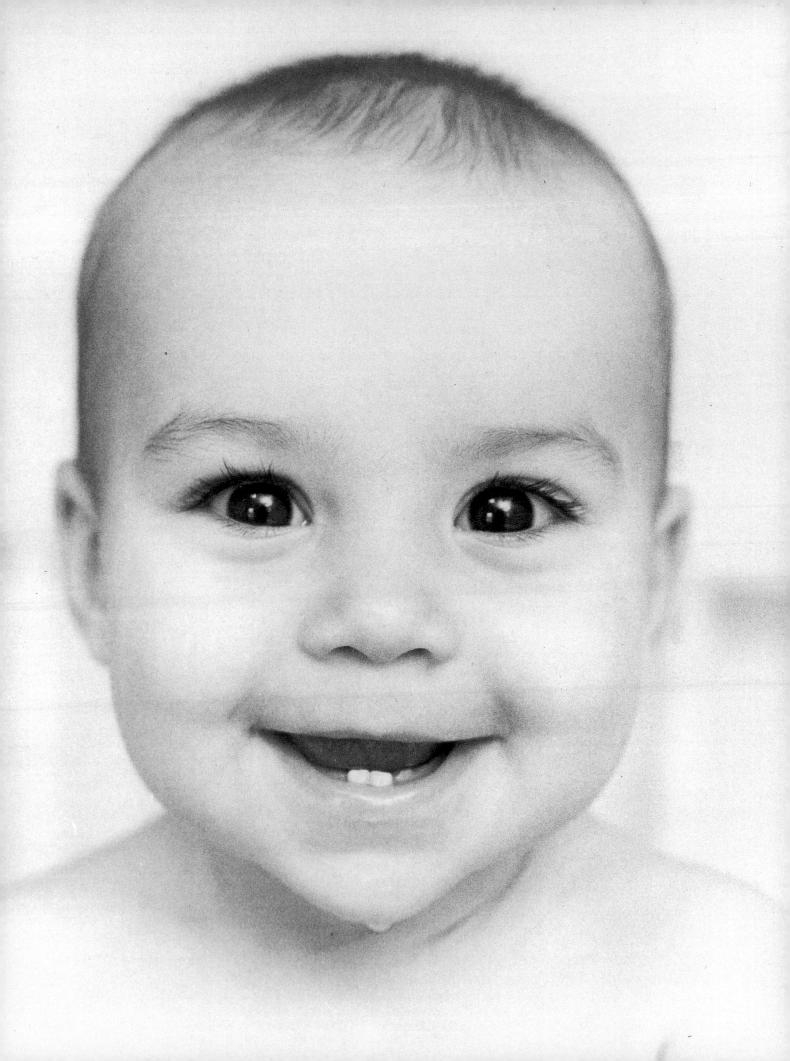

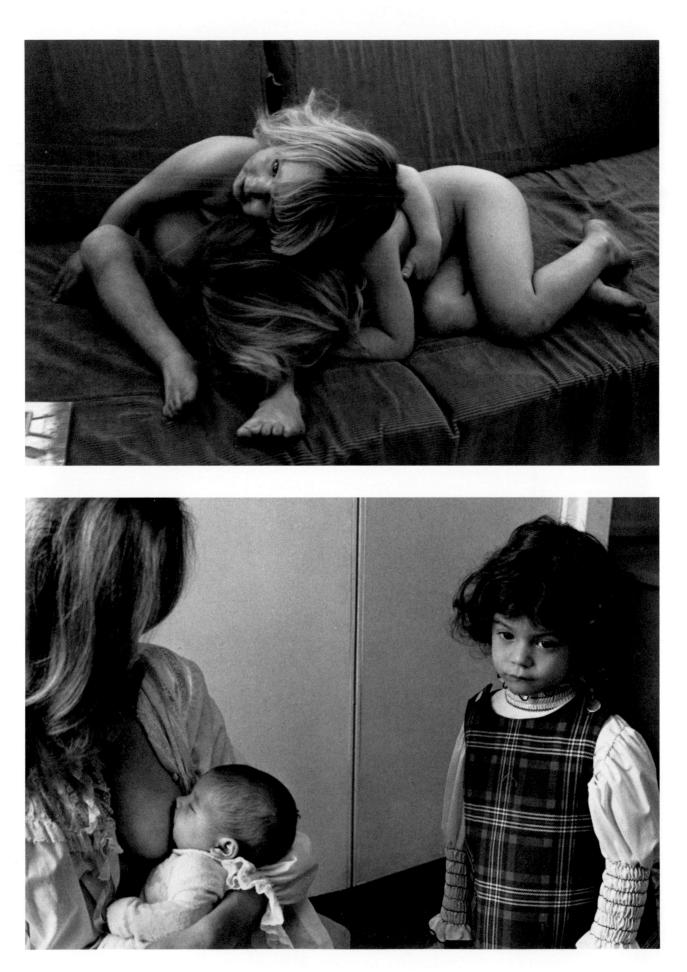